POCKETFUL
of POULTRY

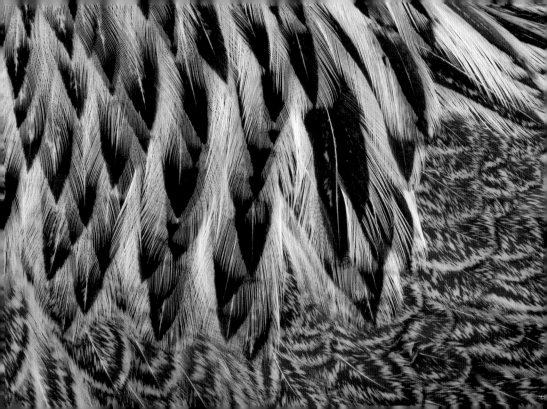

POCKETFUL of POULTRY

Chickens • Ducks • Geese • Turkeys

Carol Ekarius

Storey Publishing

The mission of Storey Publishing is to serve our customers by publishing practical information that encourages personal independence in harmony with the environment.

Edited by Sarah Guare

Book design by Chen Design Associates

Cover and interior photographs by © Adam Mastoon, except for those by © Cheryl Barnaba: 28, 50, 54, 68, 85 right, 100, 132, and 201 left; © Kevin Fleming: 32 and 33; © Stephen Green-Armytage: 194 and 198; © www.mypetchicken.com: 112; and Joel Schroeder: 92 and 93

The information in this book is true and complete to the best of our knowledge. All recommendations are made without guarantee on the part of the author or Storey Publishing. The author and publisher disclaim any liability in connection with the use of this information. For additional information, please contact Storey Publishing, 210 MASS MoCA Way, North Adams, MA 01247.

Storey books are available for special premium and promotional uses and for customized editions. For further information, please call 1-800-793-9396.

Printed in China by Toppan Leefung Printing Ltd.

10 9 8 7 6 5 4

Library of Congress
Cataloging-in-Publication Data on file

◊ **Contents**

◊ **Appendixes**

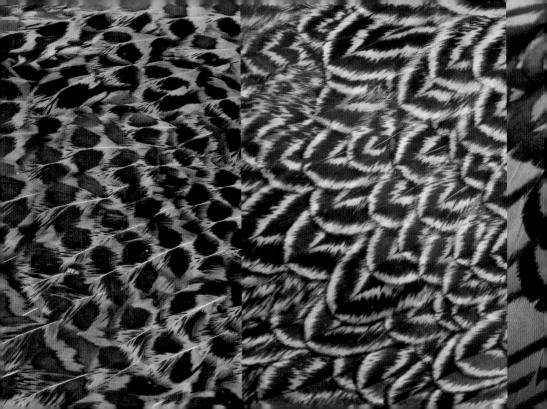

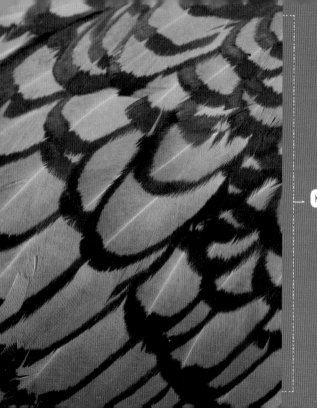

CHICKENS

◊ Ameraucana

Breeders developed the Ameraucana to standardize a bird with the blue-egged trait of its parent stock, the Araucana, but without the Araucana's gene that causes some chicks to die during incubation.

> HEN

Ornamental

Laying

Meat

Size: Standard Cock. 6.5 lb. (3 kg) / Hen. 5.5 lb. (2.5 kg). Bantam Cock. 30 oz. (850 g) / Hen. 26 oz. (740 g).

Notable Features: Pea comb; small or absent wattles; small, round earlobes; all are red. Many color varieties.

Place of Origin: United States.

Conservation Status: Not applicable.

Special Qualities: Lays blue eggs in various shades. Has an impressively long laying season.

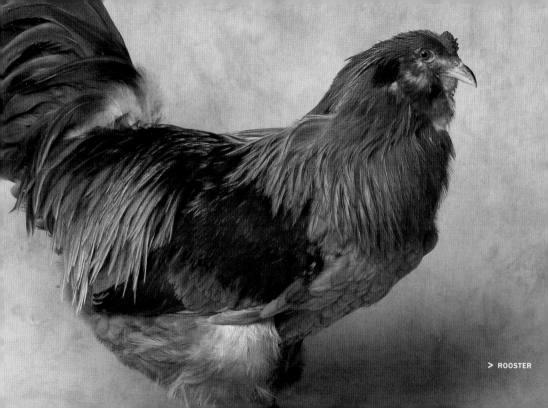

> ROOSTER

⟡ American Game Bantam

This breed was developed during the 1940s by crossing a common "pit game" bantam (a small fighting bird) with Red Jungle Fowl (small birds that are fast runners). American Games are hardy, vigorous, and easy for beginners to raise.

Ornamental

Laying

Meat

> ROOSTER

Size:	**Cock.** 30 oz. (850 g) / **Hen.** 27 oz. (765 g).
Notable Features:	Small, thin, smooth wattles and ear lobes, bright red in most varieties. Many color varieties.
Place of Origin:	New Jersey.
Conservation Status:	Not applicable.
Special Qualities:	Males fight and should not be confined together.

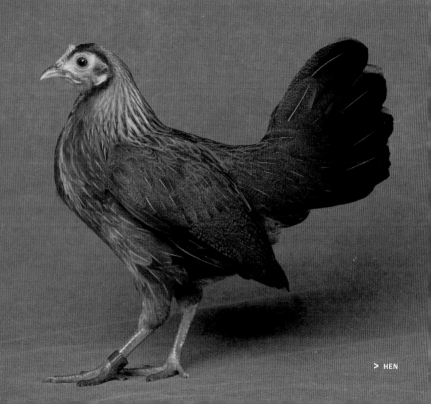

> HEN

The fabulous feathers of a Blue Golden Duckwing American Game Bantam rooster.

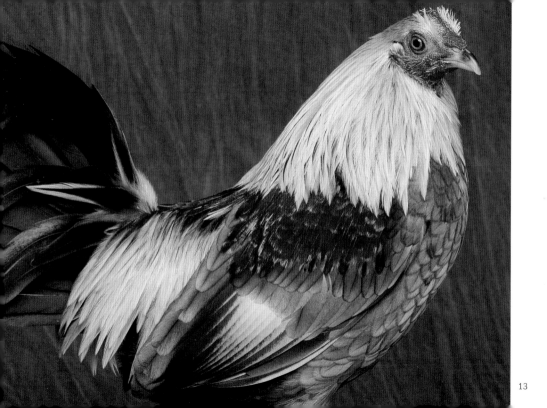

◊ Ancona

Originating along the coast of Italy, in the town of the same name, Anconas are closely related to the Leghorns. In fact, when they arrived in North America some people referred to them as "Mottled Leghorns" or "Black Leghorns."

Ornamental

Laying

Meat

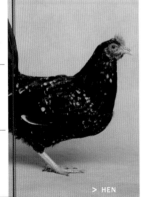

> HEN

Size:	**Standard Cock.** 6 lb. (2.75 kg) / **Hen.** 4.5 lb. (2 kg). **Bantam Cock.** 26 oz. (740 g) / **Hen.** 22 oz. (625 g).
Notable Features:	Comb either single or rose. Bright red wattles and white earlobes. Shiny greenish black plumage with white mottling.
Place of Origin:	Italy.
Conservation Status:	Threatened.
Special Qualities:	Excellent layer of large white eggs. Lays longer into the winter without supplemental light than most breeds.

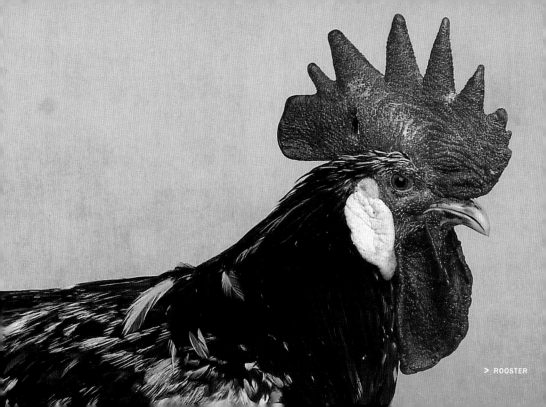

> ROOSTER

◊ Andalusian

Though once referred to as the Blue Minorca, this breed is now known as the Andalusian for its namesake province, Andalusia, Spain. These active and talkative birds are larger than Leghorns.

Ornamental

Laying

Meat

Size:	**Standard Cock.** 7 lb. (3.2 kg) / **Hen.** 5.5 lb. (2.5 kg). **Bantam Cock.** 28 oz. (795 g) / **Hen.** 24 oz. (680 g).
Notable Features:	Moderately long, thin, bright red wattles and medium-size, almond-shaped, bright white earlobes.
Place of Origin:	Spain.
Conservation Status:	Critical.
Special Qualities:	Ornamental layer. Hybrid characteristic yields Black, Splash, and Blue chicks from matings of Blue Andalusian parents.

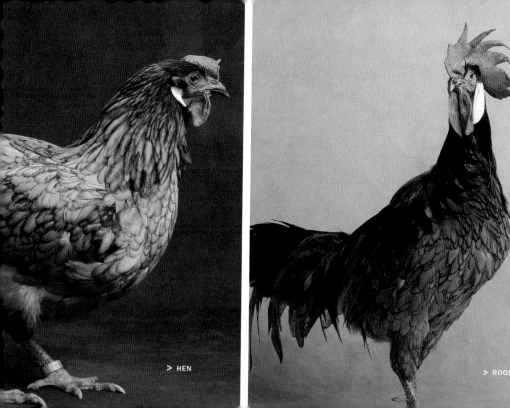

> HEN

> ROOSTER

◊ Appenzeller

Appenzellers are wild-looking birds, but they are quite hardy and make good fliers. Of the two varieties, only one, the Spitzhauben, is available in North America.

Ornamental

Laying

Meat

> ROOSTER

Size: Standard Cock. 4.5 lb. (2 kg) / Hen. 3.5 lb. (1.6 kg). Bantam Cock. 24 oz. (680 g) / Hen. 20 oz. (570 g).

Notable Features: Pouf of head feathers. Red, V-shaped comb. Color varieties are Black, Gold Spangled, and Silver Spangled (shown).

Place of Origin: Switzerland.

Conservation Status: Not applicable.

Special Qualities: Ornamental layer of medium-size, white eggs. Birds are very active and won't take to close confinement.

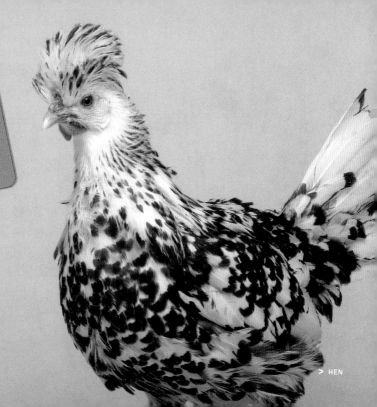

> HEN

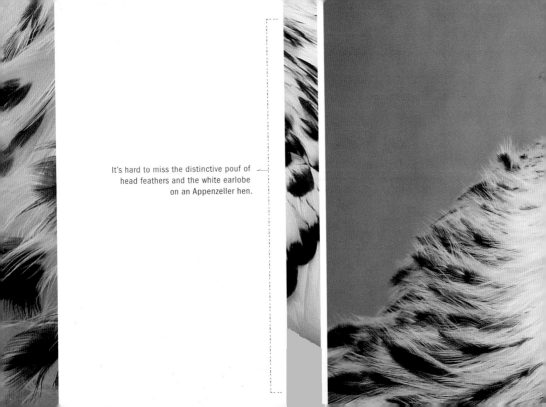

It's hard to miss the distinctive pouf of head feathers and the white earlobe on an Appenzeller hen.

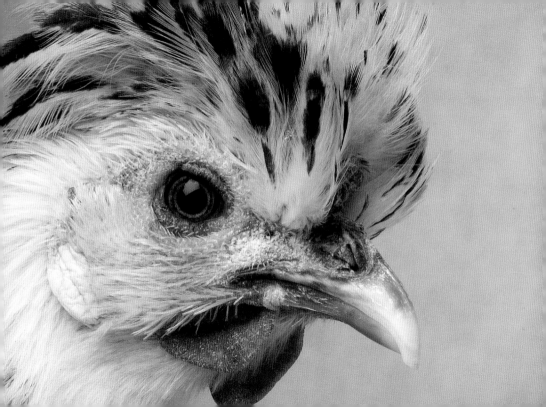

◊ **Araucana**

Truly unique, Araucanas were initially developed from Collonca and Quetero birds that were kept by the Mapuche, a native Chilean tribe. Araucanas lack a tail and have a tuft of ear feathers. Hens lay pale blue eggs with a greenish tint.

Ornamental

Laying

Meat

> HEN

Size: Standard Cock. 5 lb. (2.25 kg) / **Hen.** 4 lb. (1.8 kg). Bantam Cock. 26 oz. (740 g) / **Hen.** 24 oz. (680 g).

Notable Features: Small pea comb; small or absent wattles; very small earlobes covered by tuft; all are bright red. No tail.

Place of Origin: Chile.

Conservation Status: Study.

Special Qualities: Has a lethal allele combination; some chicks die during incubation.

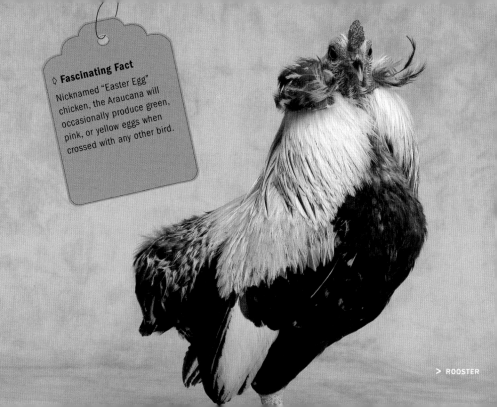

◊ **Fascinating Fact**

Nicknamed "Easter Egg" chicken, the Araucana will occasionally produce green, pink, or yellow eggs when crossed with any other bird.

> ROOSTER

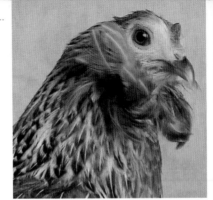

The tuft of ear feathers on this hen (top) and rooster (bottom) are thanks to the Quetero, one of the Araucana's progenitors. To the far right is a close-up of a Golden Duckwing hen's wing.

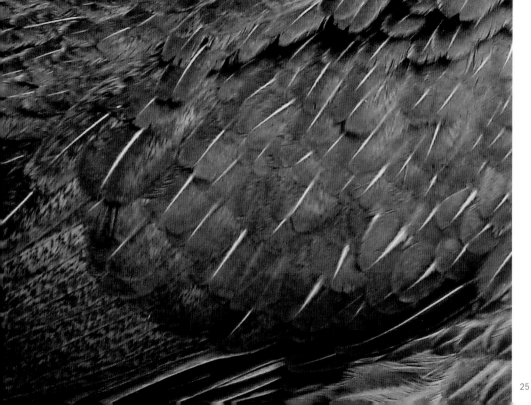

◊ Aseel

One of the oldest game breeds, the Aseel (or Asil) was bred in India and surrounding countries for over two thousand years. Males and females are extremely aggressive, so the breed is best suited for experienced poultry keepers.

Ornamental

Laying

Meat

> HEN

Size:	**Cock.** 5.5 lb. (2.5 kg) / **Hen.** 4 lb. (1.8 kg).
Notable Features:	Small, bright red pea comb and ear lobes. No wattles. Yellow to horn beak; pearl eyes; yellow shanks and toes.
Place of Origin:	India.
Conservation Status:	Critical.
Special Qualities:	Prehistoric-looking bird and parent to the Cornish. Highly aggressive.

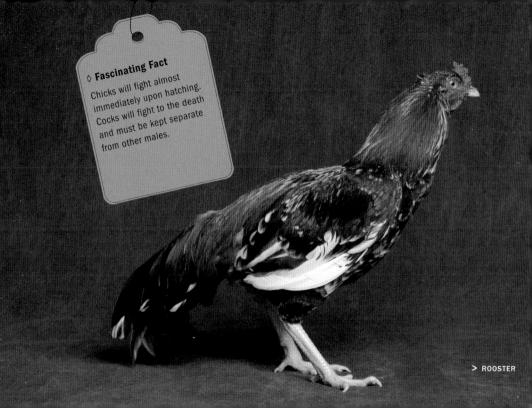

◊ **Fascinating Fact**

Chicks will fight almost immediately upon hatching. Cocks will fight to the death and must be kept separate from other males.

> ROOSTER

◊ Australorp

Australia's "national breed," the Australorp is an excellent utility bird. It is a great layer, but its meaty body and pinkish white skin make it a good dual-purpose bird.

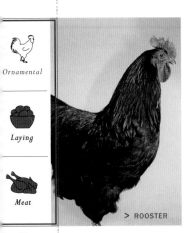

Ornamental

Laying

Meat

> ROOSTER

Size: Standard Cock. 8.5 lb. (3.9 kg) / **Hen.** 6.5 lb. (3 kg). **Bantam Cock.** 30 oz. (850 g) / **Hen.** 26 oz. (740 g).

Notable Features: Loose, fluffy feathers. Black beak; dark brown eyes; black to dark slate shanks; pinkish white bottoms of feet.

Place of Origin: Australia.

Conservation Status: Recovering.

Special Qualities: Very hardy.

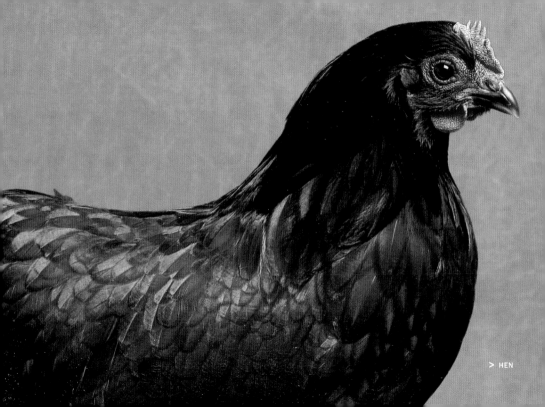

> HEN

◊ Bearded d'Anvers Bantam

Formerly known as the Antwerp Belgian, the d'Anvers is a true bantam (it does not have a larger counterpart). Its predecessors existed in the Netherlands and Belgium since the middle of the seventeenth century.

Ornamental

Laying

Meat

> ROOSTER

Size: **Cock.** 26 oz. (740 g) / **Hen.** 22 oz. (625 g).

Notable Features: Asymmetric body. Bright red, small rose comb red with rounded points. Small or absent red wattles. Many color varieties.

Place of Origin: Belgium.

Conservation Status: Not applicable.

Special Qualities: Good layer of small white eggs. Active bird; does well in small areas; tames nicely.

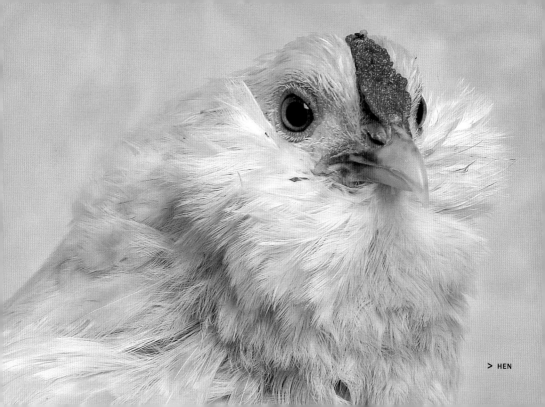

> HEN

▷ Blue Hen of Delaware

This breed is essentially a unique strain developed from Old English Games hundreds of years ago. The Blue Hen of Delaware is the state bird of Delaware and the mascot of the University of Delaware.

Ornamental

Laying

Meat

> HEN

Size: **Cock.** 5 lb. (2.25 kg) / **Hen.** 4 lb. (1.8 kg).

Notable Features: Willow shanks and toes. Steely blue front of neck, lower body, and tail; rest of bird can be shades of yellow and orange.

Place of Origin: Delaware.

Conservation Status: Not applicable.

Special Qualities: Breeding of Blue Hens yields three colors: a steely blue, a black, and a splash.

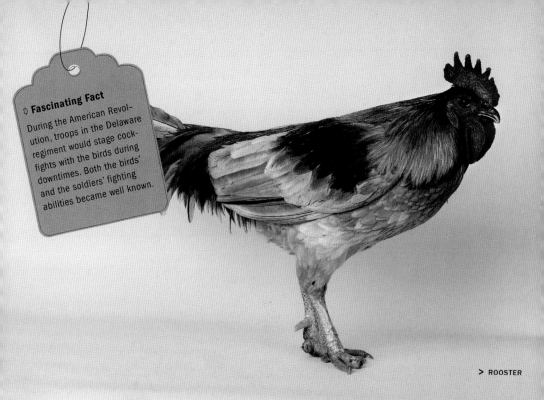

Fascinating Fact

During the American Revolution, troops in the Delaware regiment would stage cockfights with the birds during downtimes. Both the birds' and the soldiers' fighting abilities became well known.

> ROOSTER

◊ Booted Bantam & Bearded d'Uccle

Developed in the town of Uccle, Belgium, these two birds are recognized as separate but closely related breeds. The only difference is that the d'Uccle (shown here) has a full beard and muffs and the Booted doesn't.

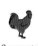

Ornamental

Laying

Meat

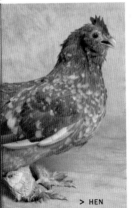

> HEN

Size:	**Cock.** 26 oz. (740 g) / **Hen.** 22 oz. (625 g).
Notable Features:	Horn beak; reddish bay eyes; slate shanks and toes. Many color varieties.
Place of Origin:	Belgium.
Conservation Status:	Not applicable.
Special Qualities:	A nice disposition for showy backyard and barnyard flocks. Good layers (of very small white eggs), for bantams.

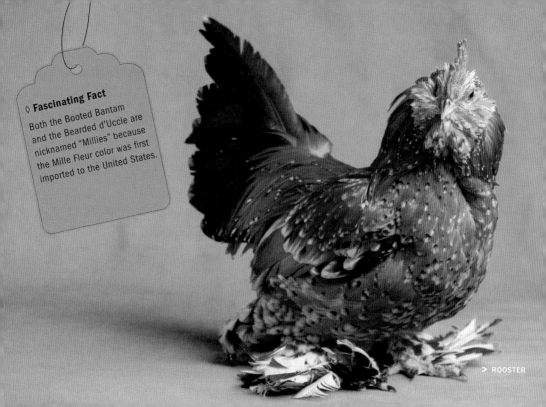

> ROOSTER

A Self Blue d'Uccle rooster.

The Mille Fleur coloring on this d'Uccle hen is particularly striking, as are her muffs (far right).

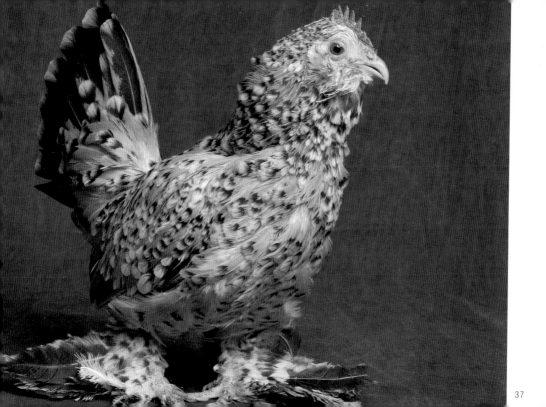

◊ Brahma

Named for the Brahmaputra River in India, this is one of the largest breeds of chicken. Brahmas are mellow and quite hardy, standing up well to both heat and cold.

Ornamental

Laying

Meat

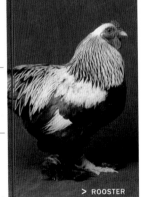

> ROOSTER

Size: Standard Cock. 12 lb. (5.45 kg) / Hen. 9.5 lb. (4.3 kg). Bantam Cock. 38 oz. (1.1 kg) / Hen. 34 oz. (965 g).

Notable Features: Red pea comb; red wattles and ear lobes. Upright posture and lovely color patterns.

Place of Origin: United States.

Conservation Status: Watch.

Special Qualities: Good winter layer of brown eggs.

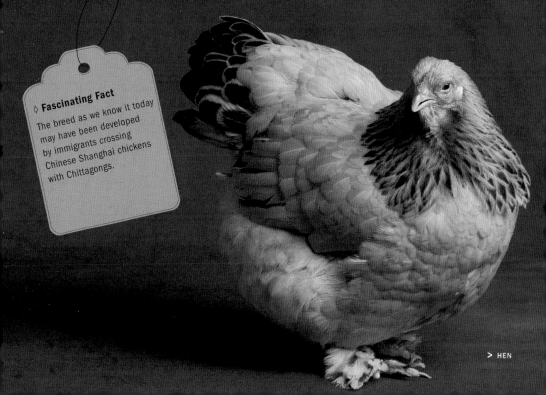

> HEN

Though considered Dark, this Brahma hen's plumage meets the description of Silver Penciled.

◊ Buckeye

An American native, the Buckeye was developed in the 1890s by Nettie Metcalf, a farm wife from Ohio. It is the only American breed to sport a pea comb — and the only one developed solely by a woman.

Ornamental

Laying

Meat

Size:	**Standard Cock.** 9 lb. (4.1 kg) / **Hen.** 6.5 lb. (3 kg). **Bantam Cock.** 34 oz. (965 g) / **Hen.** 28 oz. (795 g).
Notable Features:	Bright red pea comb; bright red, well-rounded wattles; bright red earlobes. Rich, lustrous, reddish brown or mahogany plumage.
Place of Origin:	United States.
Conservation Status:	Critical.
Special Qualities:	Nice disposition and very cold hardy. Good dual-purpose characteristics with very dark dark meat.

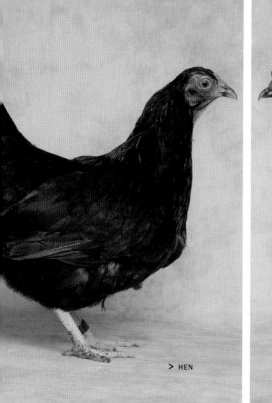

> HEN

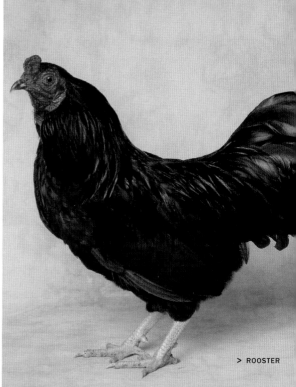

> ROOSTER

◊ Campine

Thought to be descended from Egyptian Fayoumis, Campines are good foragers and flyers. They are largely treated as ornamentals in North America, yet they are a good laying breed.

Ornamental

Laying

Meat

> ROOSTER

Size: Standard Cock. 6 lb. (2.75 kg) / **Hen.** 4 lb. (1.8 kg). **Bantam Cock.** 26 oz. (740 g) / **Hen.** 22 oz. (625 g).

Notable Features: Lustrous golden or silver plumage solid on head and hackles, barred on body. Roosters lack long tail feathers and pointed hackle and saddle feathers.

Place of Origin: Belgium.

Conservation Status: Critical.

Special Qualities: Prolific layer of medium white eggs.

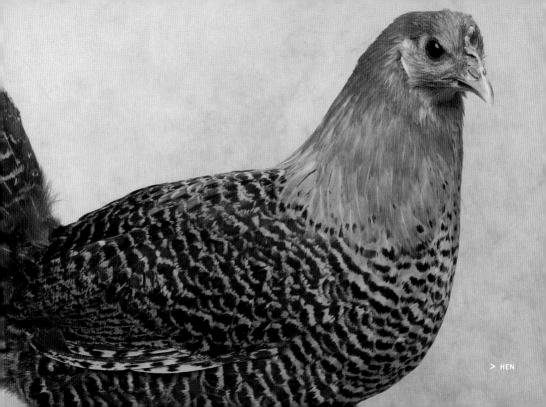

> HEN

◊ Catalana

Also known as the Buff Catalana or the Catalana del Prat Leonada, the breed is known for hardiness, particularly its ability to handle extreme heat, and for good foraging ability. It does not do well in tight confinement.

Ornamental

Laying

Meat

> HEN

Size:	**Standard Cock.** 8 lb. (3.6 kg) / **Hen.** 6 lb. (2.75 kg). **Bantam Cock.** 32 oz. (910 g) / **Hen.** 28 oz. (795 g).
Notable Features:	Medium-size, bright red single comb has six points. Large, bright red wattles. Large, bright white earlobes.
Place of Origin:	Spain.
Conservation Status:	Critical.
Special Qualities:	Ornamental bird with dual-purpose characteristics. Produces meat and plenty of medium to large white or light pinkish cream eggs.

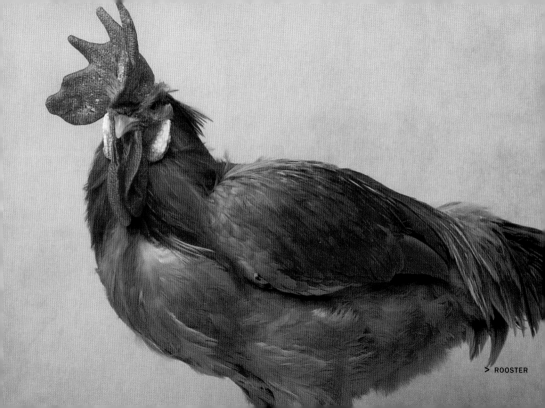

> ROOSTER

◊ Chantecler

Canadian breeders developed the Chantecler to be a general-purpose fowl that would lay through much of the cold Canadian winter. The breed is quite gentle but somewhat high-strung and a bit edgy in confinement.

Ornamental

Laying

Meat

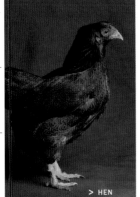

> HEN

Size: Standard Cock. 8.5 lb. (3.9 kg) / Hen. 6.5 lb. (3 kg). Bantam Cock. 34 oz. (965 g) / Hen. 30 oz. (850 g).

Notable Features: Cushion-shaped comb. Very small, bright red comb, wattles, and earlobes. Tight feathering and heavy down.

Place of Origin: Canada.

Conservation Status: Critical.

Special Qualities: Very hardy. Dual-purpose bird that lays light brown eggs.

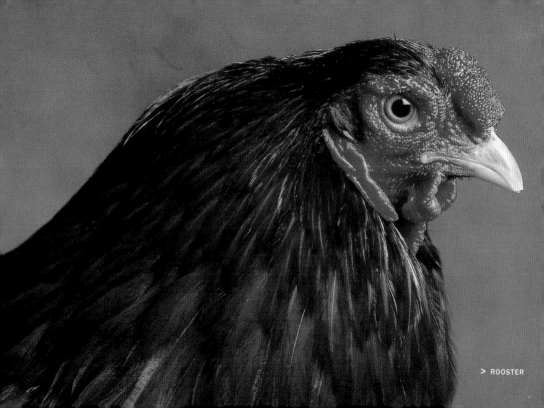

> ROOSTER

◊ Cochin

This fluffy bird was a world-wide sensation when it was first developed. It initiated the "Hen Craze" — a period from the 1880s through the early 1900s when people began breeding birds for aesthetic, not production, traits.

Ornamental

Laying

Meat

> ROOSTER

Size: Standard Cock. 11 lb. (5 kg) / **Hen.** 8.5 lb. (3.6 kg). **Bantam Cock.** 32 oz. (910 kg) / **Hen.** 28 oz. (795 g).

Notable Features: Dense, long, soft plumage. Unique cushion of feathers on back and saddle. Over 15 color varieties.

Place of Origin: China.

Conservation Status: Watch.

Special Qualities: A large, attractive bird that is popular for showing. Good winter layer with good mothering abilities.

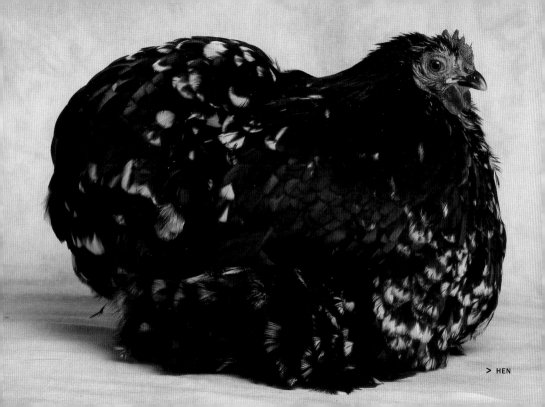

> HEN

The Cochin's soft, fluffy tail and beautiful colors, as seen on this Brown Red rooster here and to the far right, helped fuel the "Hen Craze."

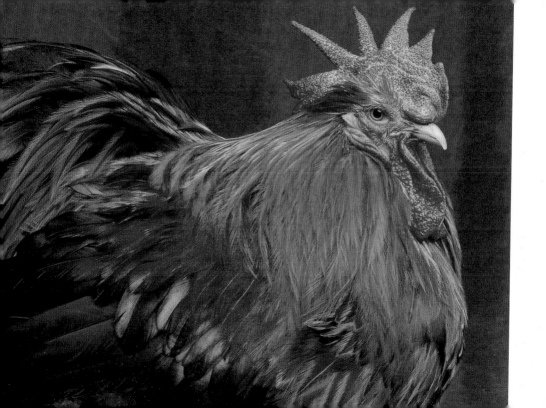

◊ Cornish

The bruiser of the chicken world, the Cornish breed is the foundation of our modern broiler industry. It was developed in Cornwall, England, and has a strong game bird heritage, which accounts for its alias, the Indian Game.

Ornamental

Laying

Meat

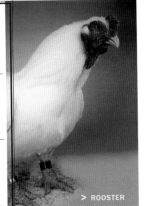

> ROOSTER

Size:	Standard Cock. 10.5 lb. (4.75 kg) / Hen. 8 lb. (3.6 kg). Bantam Cock. 44 oz. (1.25 kg) / Hen. 36 oz. (1 kg).
Notable Features:	Wide, deep breast; large, wide-set legs. Hard feathers are narrow and short with a tough shaft and no fluff. Heart-shaped back when viewed from above.
Place of Origin:	England.
Conservation Status:	Watch.
Special Qualities:	Excellent conversion of feed to meat.

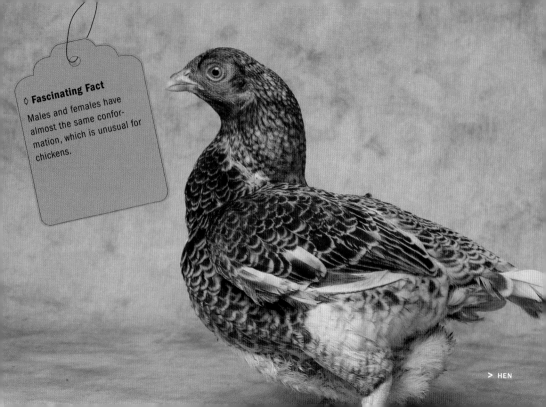

◊ **Fascinating Fact**

Males and females have almost the same conformation, which is unusual for chickens.

> HEN

◊ Crevecoeur

One of the oldest breeds in France, the Crevecoeur is named for a town in the province of Normandy. Crevecoeurs are raised primarily as show birds in North America and England.

Ornamental

Laying

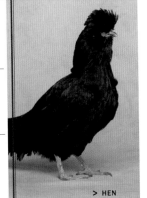

> HEN

Meat

Size: **Standard Cock.** 8 lb. (3.6 kg) / **Hen.** 6.5 lb. (3 kg). **Bantam Cock.** 30 oz. (850 g) / **Hen.** 26 oz. (740 g).

Notable Features: V-shaped, bright red comb. Black and horn beak; reddish bay eyes; leaden blue shanks and toes. Crest of head feathers.

Place of Origin: France.

Conservation Status: Critical.

Special Qualities: Traditionally used as a dual-purpose bird in France, laying chalky white eggs, but now very rare worldwide.

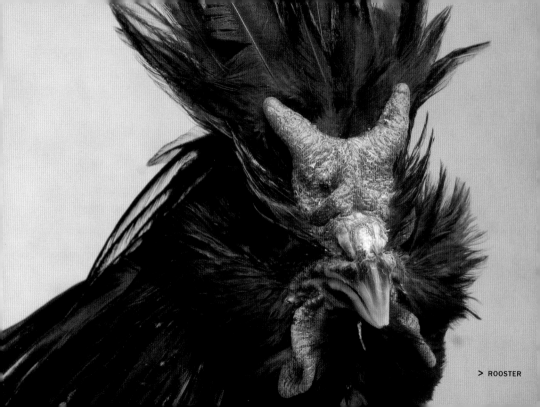

> ROOSTER

▷ Cubalaya

Cubalayas have been bred in Cuba as triple-purpose birds used for egg production, game, and meat. As game birds go, they are mild-mannered — they are less likely to fight other birds than most games and are easily tamed.

Ornamental

Laying

Meat

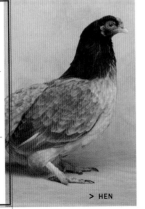

> HEN

Size: Standard Cock. 6 lb. (2.75 kg) / Hen. 4 lb. (1.8 kg). Bantam Cock. 26 oz. (740 g) / Hen. 22 oz. (625 g).

Description: Small, bright red pea comb. White or light horn beak; reddish bay eyes; pinkish white shanks and toes in most of its four varieties.

Place of Origin: Cuba.

Conservation Status: Threatened.

Special Qualities: Good foragers; don't tolerate confinement. Can be noisy; tolerant of high heat and humidity.

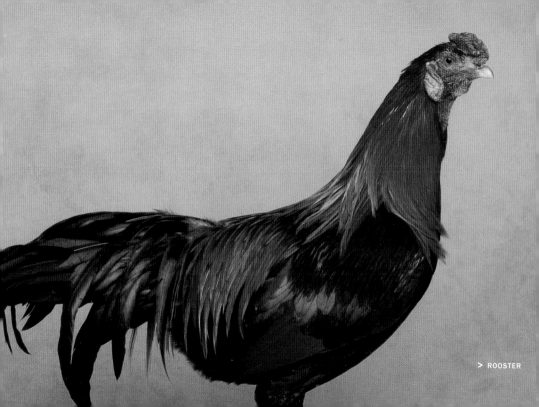

> ROOSTER

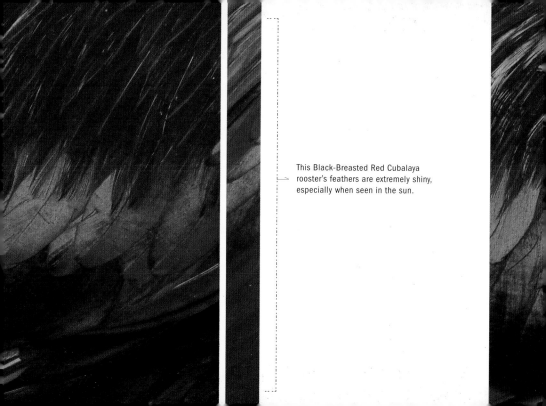

This Black-Breasted Red Cubalaya rooster's feathers are extremely shiny, especially when seen in the sun.

◊ Delaware

From roughly 1940 to 1960, when it was replaced by the Cornish–Plymouth Rock cross, the Delaware was the dominant breed in the broiler industry of Delaware's Delmarva Peninsula. It still makes an excellent dual-purpose barnyard bird.

Ornamental

Laying

Meat

Size: **Standard Cock.** 8.5 lb. (3.9 kg) / **Hen.** 6.5 lb. (3 kg).
Bantam Cock. 34 oz. (965 g) / **Hen.** 30 oz. (850 g).

Notable Features: White to silvery white body and breast; white tail and wings with some black barring; white shaft and quill on all feathers.

Place of Origin: United States.

Conservation Status: Critical.

Special Qualities: Excellent broilers for small-scale meat production. Hens lay large brown eggs. Adapts well to confinement; can also be free-range.

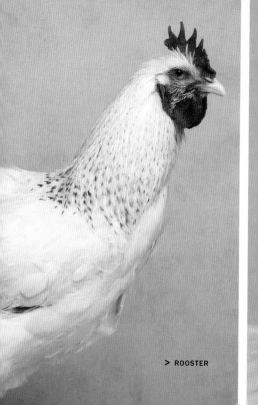

> ROOSTER

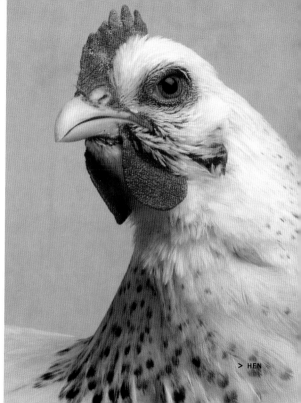

> HEN

◊ Dominique

The Dominique was the most common backyard bird in the United States from the mideighteenth century to the midnineteenth century, when it was replaced by the Barred Plymouth Rock. It is calm, genial, and easy to show.

Ornamental

Laying

Meat

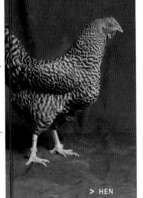

> HEN

Size: **Standard Cock.** 7 lb. (3.2 kg) / **Hen.** 5 lb. (2.25 kg). **Bantam Cock.** 28 oz. (795 g) / **Hen.** 24 oz. (680 g).

Notable Features: Bright red rose comb. Plumage has distinctive black and creamy white barring pattern. Males may be a shade lighter than females.

Place of Origin: United States.

Conservation Status: Watch.

Special Qualities: The oldest U.S. breed, and still a good dual-purpose bird. Lays medium-size, brown eggs.

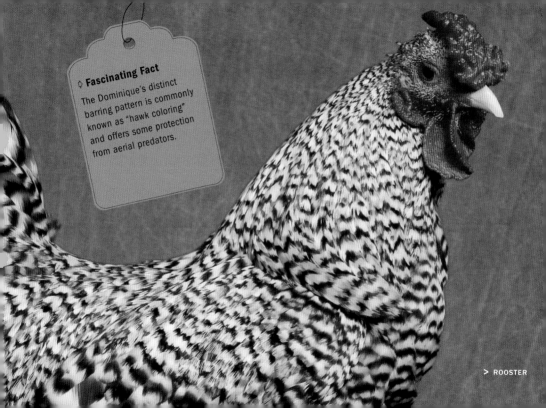

◊ **Fascinating Fact**

The Dominique's distinct barring pattern is commonly known as "hawk coloring" and offers some protection from aerial predators.

> ROOSTER

◊ Dorking

The English bred the Dorking as a table bird, renowned for its fine-textured and very white meat. Some of the earliest English settlers to North America probably brought them to the United States.

Ornamental

Laying

Meat

> HEN

Size:	**Standard Cock.** 9 lb. (4.1 kg) / **Hen.** 7 lb. (3.2 kg). **Bantam Cock.** 36 oz. (1 kg) / **Hen.** 32 oz. (910 g).
Notable Features:	Bright red single comb with six upright points. Large, bright red rose comb, square in front and terminating in a spike.
Place of Origin:	Britain.
Conservation Status:	Threatened.
Special Qualities:	Calm, docile, and adaptable; a great choice for a backyard bird. Hens lay a fair amount of creamy white eggs.

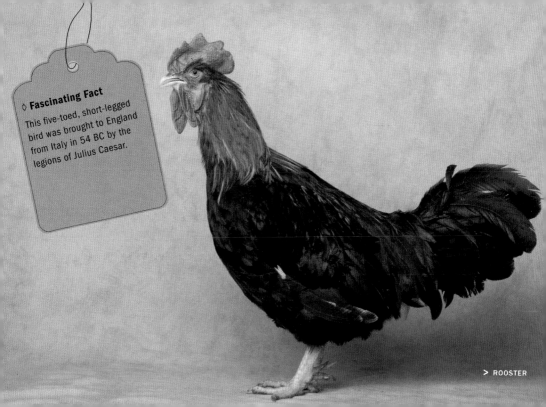

◇ **Fascinating Fact**

This five-toed, short-legged bird was brought to England from Italy in 54 BC by the legions of Julius Caesar.

> ROOSTER

◇ Dutch Bantam

This breed was developed during the seventeenth century in Holland from birds that Dutch seamen acquired on Bantam Island in the Dutch East Indies (today part of Indonesia) to supply meat and eggs during the voyage.

Ornamental

Laying

Meat

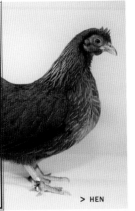

> HEN

Size:	**Cock.** 21 oz. (595 g) / **Hen.** 20 oz. (570 g).
Notable Features:	Bluish horn beak; reddish bay eyes; slaty blue shanks and toes. Upright carriage; attractive, long tail. Ten color varieties.
Place of Origin:	Holland.
Conservation Status:	Not applicable.
Special Qualities:	Gives a good supply of small eggs and is now a favorite for exhibition.

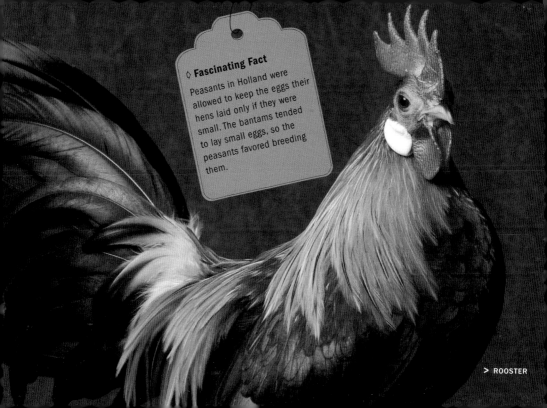

◊ **Fascinating Fact**

Peasants in Holland were allowed to keep the eggs their hens laid only if they were small. The bantams tended to lay small eggs, so the peasants favored breeding them.

> ROOSTER

◊ **Faverolle**

Named for a village in France, the Faverolle was developed in the midnineteenth century as a good dual-purpose breed known for fine table quality and strong production of brown eggs in winter.

Ornamental

Laying

Meat

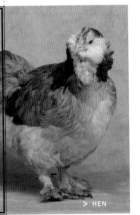

> HEN

Size: **Standard Cock.** 8 lb. (3.6 kg) / **Hen.** 6.5 lb. (3 kg). **Bantam Cock.** 30 oz. (850 g) / **Hen.** 26 oz. (740 g).

Notable Features: Five toes; lightly feathered legs; beard and muffs; broad breast carried well forward. Five color varieties.

Place of Origin: France.

Conservation Status: Critical.

Special Qualities: Very gentle; good for kids. Hens lay plenty of medium-size, light brown eggs and have good winter production.

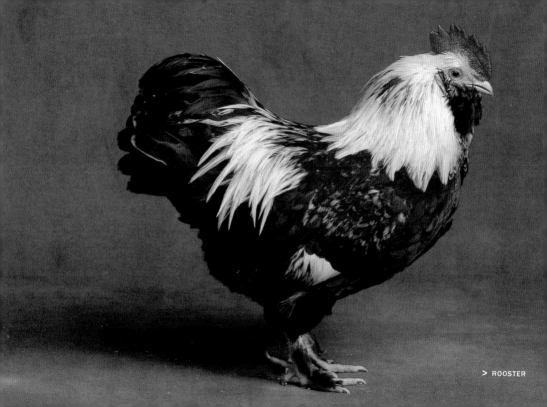

> ROOSTER

◊ Fayoumi

A small, active bird, the Fayoumi has been known in Egypt since the time of the pharaohs. Fayoumis are not common among breeders, though Iowa State University has maintained a flock since the 1940s.

Ornamental

Laying

Meat

Size: **Cock.** 4.5 lb. (2 kg) / **Hen.** 3.5 lb. (1.6 kg).

Notable Features: Jaunty tail with a forward tilt. Bright red single comb with six upright points.

Place of Origin: Egypt.

Conservation Status: Study.

Special Qualities: Fast to mature. Will forage for all its own food if allowed. Hens are excellent layers of small off-white eggs.

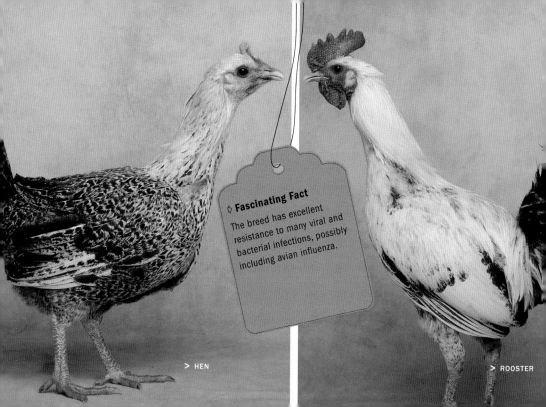

◊ **Fascinating Fact**

The breed has excellent resistance to many viral and bacterial infections, possibly including avian influenza.

> HEN

> ROOSTER

◊ Hamburg

Small yet active, Hamburgs are particularly good fliers. Thanks to their excellent foraging ability, they do very well in backyard and barnyard settings, but they perform poorly in close confinement.

Ornamental

Laying

Meat

> HEN

Size: **Standard Cock.** 5 lb. (2.25 kg) / **Hen.** 4 lb. (1.8 kg). **Bantam Cock.** 26 oz. (740 g) / **Hen.** 22 oz. (625 g). (Black and Spangled varieties may be larger.)

Notable Features: Red rose comb covered with small points. Red, well-rounded wattles. White earlobes. Several color varieties.

Place of Origin: Turkey (according to Craig Russell, a renowned poultry historian).

Conservation Status: Watch.

Special Qualities: Hens are prolific layers of relatively small white eggs. Breed is cold-hardy.

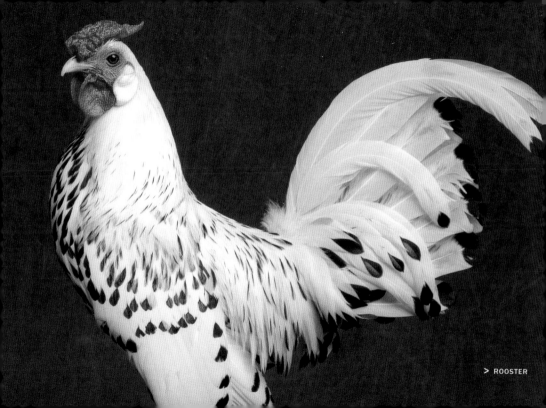

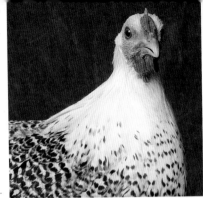

A lovely Silver Penciled Hamburg hen.

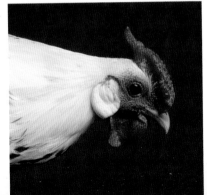

A sporty rose comb on a Hamburg rooster. At far right, the wing feathers of a Golden Penciled hen.

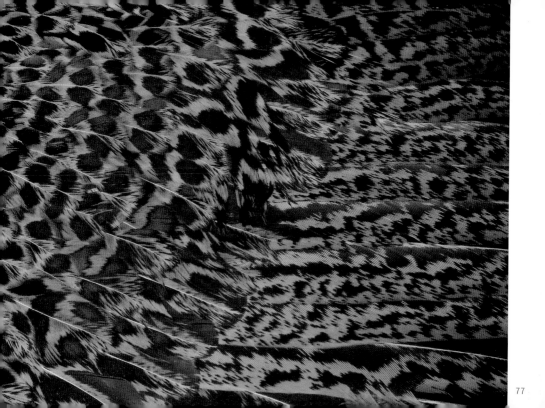

◊ Holland

During the 1930s white eggs were more rare and more profitable than brown eggs in the United States. This breed was developed in New Jersey, not Holland, by scientists who wanted to produce a dual-purpose bird that laid white eggs.

Ornamental

Laying

Meat

> HEN

Size: **Standard Cock.** 8.5 lb. (3.9 kg) / **Hen.** 6.5 lb. (3 kg). **Bantam Cock.** 34 oz. (965 g) / **Hen.** 30 oz. (850 g).

Notable Features: Bright red single comb with six points. Medium to moderately large, bright red wattles. Color varieties are Barred and White.

Place of Origin: United States.

Conservation Status: Critical.

Special Qualities: Good foragers; calm; fairly hardy. Good dual-purpose bird; hens lay lots of medium to large white eggs.

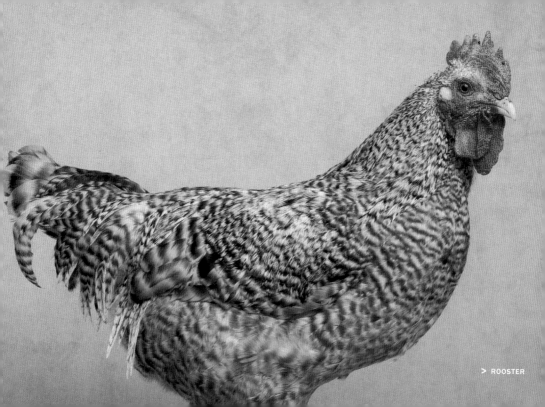

> ROOSTER

◊ Houdan

With their V-shaped comb and crest of head feathers, Houdans are quite stylish. They are also good dual-purpose birds for backyard and barnyard.

Ornamental

Laying

Meat

> ROOSTER

Size: Standard Cock. 8 lb. (3.6 kg) / Hen. 6.5 lb. (2.75 kg). Bantam Cock. 34 oz. (965 g) / Hen. 30 oz. (850 g).

Notable Features: Small, V-shaped, red comb rests against crest. Small, white earlobes hidden by crest and beard. Color varieties are Mottled and White.

Place of Origin: France.

Conservation Status: Critical.

Special Qualities: Exceptionally gentle disposition makes this bird an ideal pet. Good layer of small to medium-size white eggs.

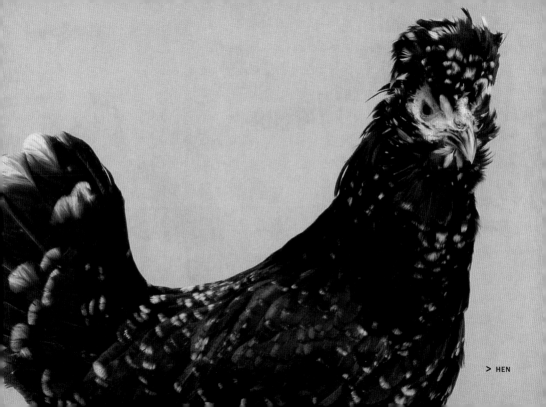

> HEN

◊ Iowa Blue

Developed around Decorah, Iowa, during the first half of the twentieth century, the Iowa Blue almost died out in the 1960s. Interested breeders like Ken Whealy of the Decorah-based nonprofit Seed Savers Exchange have been preserving it.

Ornamental

Laying

Meat

Size:	**Cock.** 7 lb. (3.2 kg) / **Hen.** 6 lb. (2.75 kg).
Notable Features:	Medium to moderately large, bright red single comb with six upright points. Bright red, medium to moderately large wattles and earlobes.
Place of Origin:	United States.
Conservation Status:	Study.
Special Qualities:	Nice backyard or barnyard dual-purpose layer of lightly tinted, brown eggs. Produces chicks that can be sexed by color when they hatch.

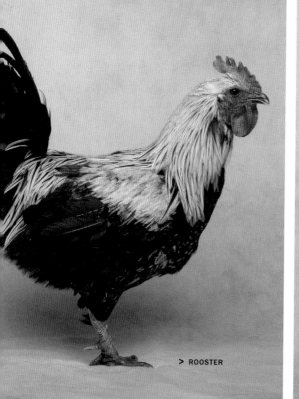

> ROOSTER

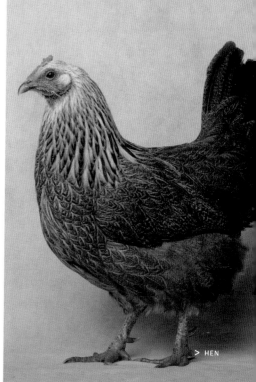

> HEN

◊ Japanese Bantam

One of the showiest of all birds, the Japanese Bantam is believed to have arrived in Japan from China very early in the 1600s. The aristocratic class bred it as an ornamental garden bird.

Ornamental

Laying

Meat

> HEN

Size: **Cock.** 26 oz. (740 g) / **Hen.** 22 oz. (625 g).

Notable Features: Relatively large comb and very large, straight, forward tail give the appearance of a V. Very short legs; long wings touch the ground. More than 15 color varieties.

Place of Origin: Japan.

Conservation Status: Not applicable.

Special Qualities: Numerous breeding challenges make it best suited for experienced breeders.

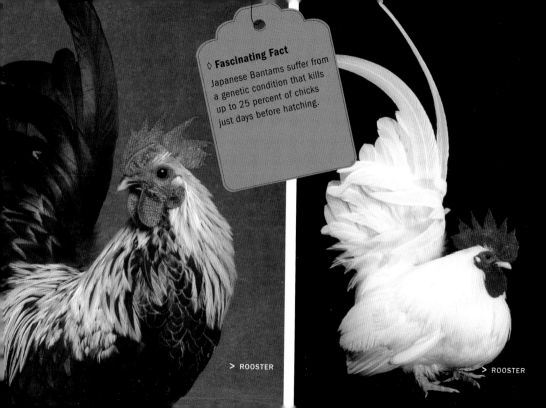

> ROOSTER

> ROOSTER

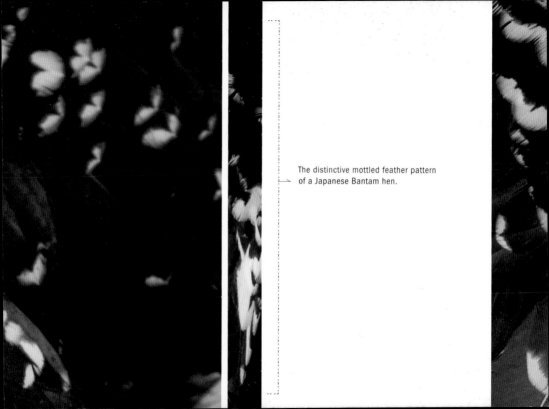

The distinctive mottled feather pattern of a Japanese Bantam hen.

◊ Java

The Java is an old American breed. It played a role in the development of the Jersey Giant, the Rhode Island Red, and the Plymouth Rock. Its single comb is unique in that the first point is above the eye, not the nostril.

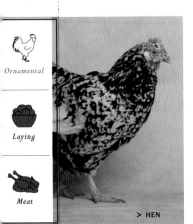

Ornamental

Laying

Meat

> HEN

Size: Standard Cock. 9.5 lb. (4.3 kg) / Hen. 7.5 lb. (3.4 kg). Bantam Cock. 36 oz. (1 kg) / Hen. 32 oz. (910 g).

Notable Features: First point of bright red, upright single comb is above eye. Color varieties are Black, Mottled, and White.

Place of Origin: United States.

Conservation Status: Critical.

Special Qualities: Practical dual-purpose bird. Hardy, and a good forager. Hens lay a fair number of medium-size, brown eggs.

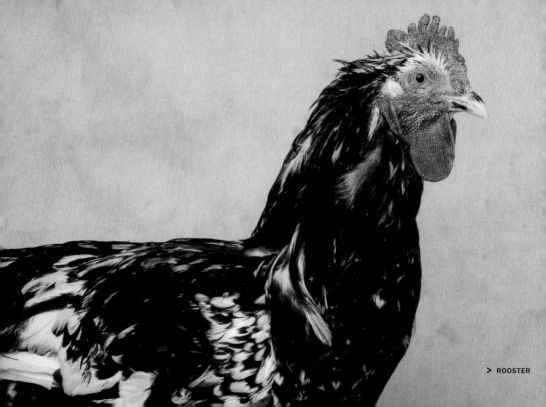

> ROOSTER

◊ Jersey Giant

As the name implies, Jersey Giants are very large birds. In fact, they are the largest chicken breed. They are slow to mature and have a poor feed-to-meat conversion, which explains why they aren't popular as a commercial broiler.

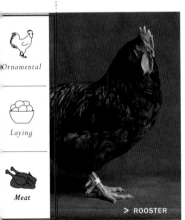

Ornamental

Laying

Meat

> ROOSTER

Size: Standard Cock. 13 lb. (5.9 kg) / **Hen.** 10 lb. (4.54 kg). **Bantam Cock.** 38 oz. (1.1 kg) / **Hen.** 34 oz. (965 g).

Notable Features: Large, bright red single comb with six upright points. Color varieties are Black, Blue, Splash, and White.

Place of Origin: United States.

Conservation Status: Watch.

Special Qualities: Good disposition. Good layer of moderately large to extra-large, brown eggs, with a long laying season.

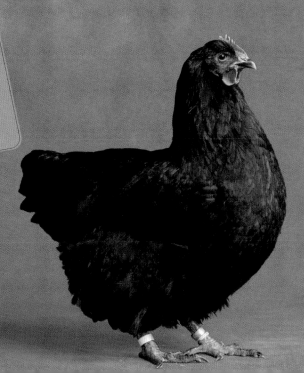

> HEN

◊ **Kraienkoppe**

By crossing Malays with Leghorns, breeders along the border of Germany and the Netherlands developed the Kraienkoppe in the 1920s. The breed is a fairly recent arrival in North America.

> HEN

Ornamental

Laying

Meat

Size: **Standard Cock.** 6 lb. (2.75 kg) / **Hen.** 4 lb. (1.8 kg).

Notable Features: Small, bright red walnut comb, wattles, and earlobes. Color varieties are Black-Breasted Red and Silver.

Place of Origin: Germany.

Conservation Status: Not applicable.

Special Qualities: Ornamental layer of medium-size, off-white eggs. Excellent forager with very high feed efficiency.

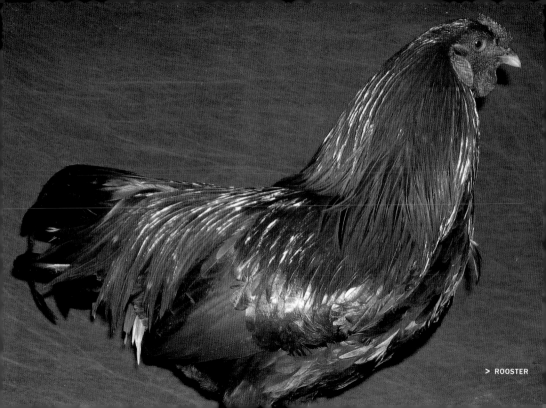

> ROOSTER

◇ La Fleche

Its shiny black plumage and large, upright, V-shaped comb that takes the appearance of horns have earned the La Fleche the nickname "devil bird." The breed is famous in France for producing large breast meat portions.

Ornamental

Laying

Meat

> HEN

Size: **Standard Cock.** 8 lb. (3.6 kg) / **Hen.** 6.5 lb. (3 kg). **Bantam Cock.** 30 oz. (850 g) / **Hen.** 26 oz. (740 g).

Notable Features: Large, bright red, V-shaped comb. Long, well-rounded, bright red wattles may be pendulous. Large, white earlobes.

Place of Origin: France.

Conservation Status: Critical.

Special Qualities: Good dual-purpose breed. Hens lay very large, white eggs well into winter months.

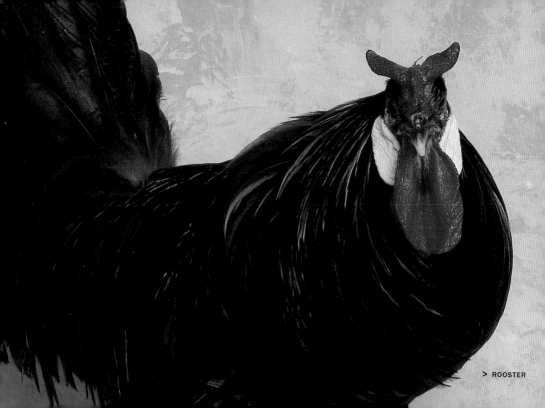

> ROOSTER

◊ Lakenvelder

With its rich black head, neck, and tail, offset by a bright white body, the Lakenvelder is a real showstopper. It is quite active and tends to be flighty.

Ornamental

Laying

Meat

> HEN

Size:	Standard Cock. 5 lb. (2.25 kg) / Hen. 4 lb. (1.8 kg). Bantam Cock. 24 oz. (680 g) / Hen. 20 oz. (570 g).
Notable Features:	Single, bright red comb with five upright points. Bright red, well-rounded wattles. White, oblong earlobes.
Place of Origin:	Germany.
Conservation Status:	Threatened.
Special Qualities:	Very handsome. Early to mature; good layer of small white eggs.

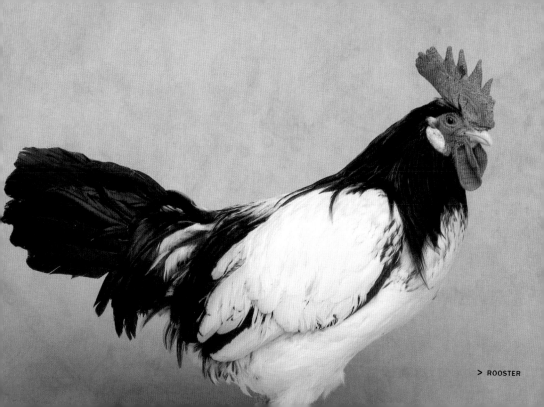

> ROOSTER

◊ Langshan

This old breed from China is named for the Langshan District, north of the Chang (Yangtze) River. It came to North America in 1876. Although Langshans make an excellent dual-purpose breed for meat and eggs, they are also ornamental.

Ornamental

Laying

Meat

Size: **Standard Cock.** 9.5. lb. (4.3 kg) / **Hen.** 7.5 lb. (3.4 kg). **Bantam Cock.** 36 oz. (1 kg) / **Hen.** 32 oz. (910 g).

Notable Features: Very tall; feathered legs; lustrous plumage; very long, full tail that is carried well above horizontal. Color varieties are Black, Blue, and White.

Place of Origin: China.

Conservation Status: Threatened.

Special Qualities: A good dual-purpose layer of brown eggs that's graceful and attractive.

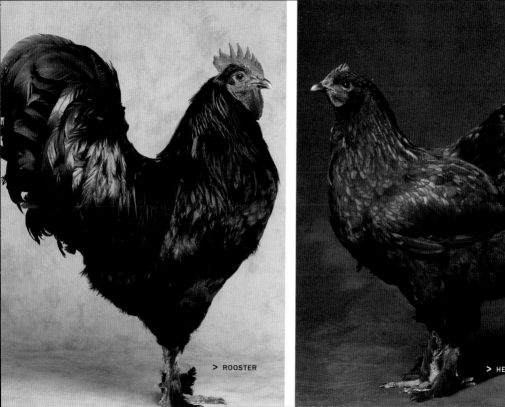

> ROOSTER

> HEN

◊ Leghorn

This breed, especially the white variety, has long been one of the most popular in the world, thanks to the Leghorn's exceptional laying ability, adaptability, and hardiness.

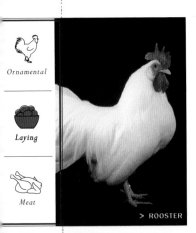

> ROOSTER

Ornamental

Laying

Meat

Size:	**Standard Cock.** 6 lb. (2.75 kg)/ **Hen.** 4.5 lb. (2 kg). **Bantam Cock.** 26 oz. (740 g) / **Hen.** 22 oz. (625 g).
Notable Features:	Bright red single comb with five points. Bright red rose comb square in front with a spike at the tip. There are more than 30 color varieties.
Place of Origin:	Italy.
Conservation Status:	Recovering.
Special Qualities:	Early to mature; excellent layer of large white eggs. Excellent feed-to-egg conversion ratio.

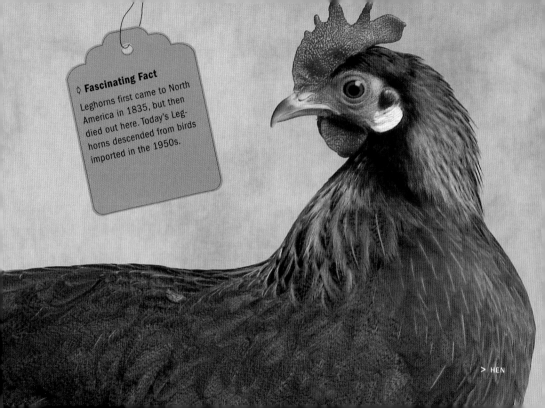

◊ **Fascinating Fact**

Leghorns first came to North America in 1835, but then died out here. Today's Leghorns descended from birds imported in the 1950s.

> HEN

◊ **Malay**

A very old breed that originated in Southeast Asia, the Malay is the tallest of the chicken breeds, towering over 3 feet (91 cm) in height. The Malay is also known for its "beetle brow," a projection of the skull over the eyes that gives it an ornery appearance.

Ornamental

Laying

Meat

Size: **Standard Cock.** 9 lb. (4.1 kg) / **Hen.** 7 lb. (3.2 kg).
Bantam Cock. 44 oz. (1.25 kg) / **Hen.** 36 oz. (1 kg).

Notable Features: Small to medium-size strawberry comb set well forward. Very tall; "beetle brow"; few or no feathers on face, throat, and breast.

Place of Origin: Southeast Asia.

Conservation Status: Critical.

Special Qualities: Mellower than other game birds. Slow to mature; doesn't do well in close confinement.

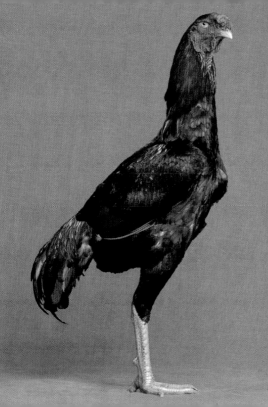

> ROOSTER

◊ Maran

Named after a French town on the Atlantic coast where they were developed, Marans are well known for their large eggs, which are the darkest brown of any chicken egg. They are active birds but adapt well to confinement.

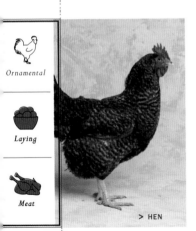

Ornamental

Laying

Meat

> HEN

Size:	**Standard Cock.** 8.5 lb. (3.9 kg) / **Hen.** 7 lb. (3.4 kg). **Bantam Cock.** 38 oz. (1.1 kg) / **Hen.** 32 oz. (910 g).
Notable Features:	Bright red, rough-textured single comb. Relatively short tail. Tight, "hard" feathers (short and narrow with no fluff). There are nine color varieties.
Place of Origin:	France.
Conservation Status:	Not applicable.
Special Qualities:	Good layer of large, dark chocolate- to copper-colored eggs. Dual-purpose bird, yielding both meat and eggs.

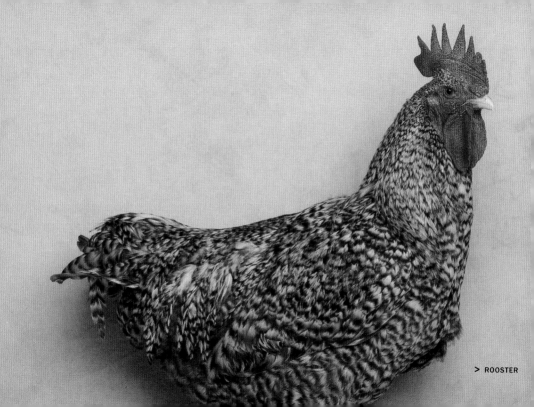

> ROOSTER

◊ Minorca

A bird of antiquity, the Minorca was known in the time of the ancient Romans. The breed is active and tends to avoid humans, though it can tolerate confinement. Its large comb, wattles, and earlobes make it susceptible to frostbite.

Ornamental

Laying

Meat

Size: **Standard Cock.** 9 lb. (4.1 kg) / **Hen.** 7.5 lb. (3.4 kg).
Bantam, Single Comb Cock. 32 oz. (910 g) / **Hen.** 26 oz. (740 g).
Bantam, Rose Comb Cock. 26 oz. (740 g) / **Hen.** 24 oz. (680 g).

Notable Features: Large comb, wattles, and earlobes; large, full tail; muscular legs set squarely under body.

Place of Origin: Spain.

Conservation Status: Watch.

Special Qualities: Ornamental layer of extra-large chalky white eggs. Early to mature.

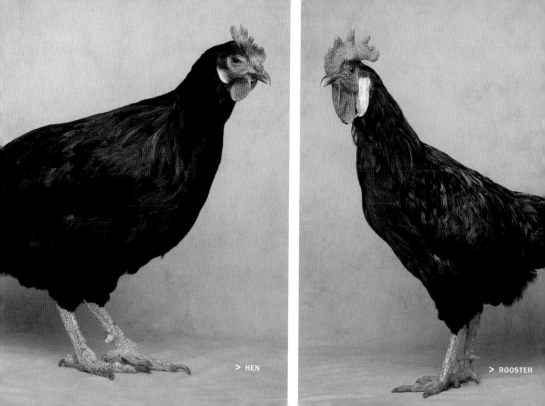

> HEN

> ROOSTER

◊ Modern Game

This breed was developed from fighting birds when cock-fighting was made illegal in England in 1849. Despite its game bird heritage, the Modern Game is strictly a fancier's bird that was never actively used in a fighting pit.

Ornamental

Laying

Meat

> HEN

Size: Standard Cock. 6 lb. (2.75 kg) / **Hen.** 4.5 lb. (2 kg). **Bantam Cock.** 22 oz. (625 g) / **Hen.** 20 oz. (570 g).

Notable Features: Small comb, wattles, and earlobes. Long, thin neck and legs; prominent breast. More than 15 color varieties.

Place of Origin: England.

Conservation Status: Study.

Special Qualities: Tall bird with distinct appearance and showy qualities. Active and noisy. Can be aggressive, but generally personable.

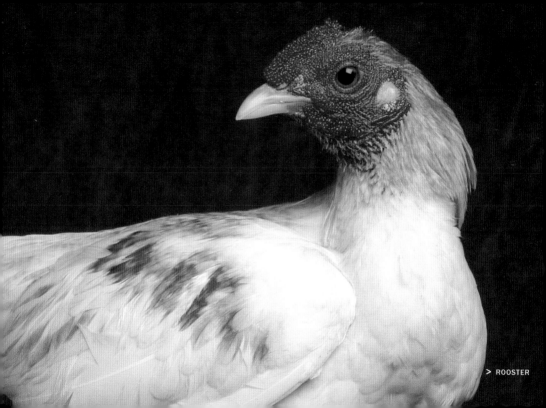

> ROOSTER

There is a wide variety of Modern Game colors, such as Blue Breasted (the wing of a Blue Breasted rooster is shown to the right) and Birchen (a Birchen rooster is shown to the far right).

Black chicken feathers like these should be shiny, reflecting the light that hits them.

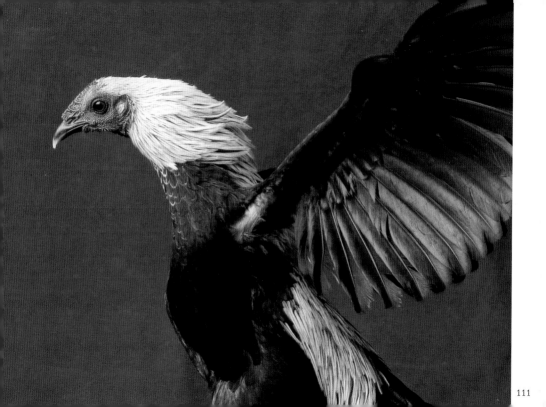

◊ Naked Neck

Appearing like a cross between a turkey and a chicken, Naked Necks are sometimes referred to as Turkens. Naked Necks can adapt to hot and cold climates, and their feed efficiency, having fewer protein-rich feathers, is very high.

Ornamental

Laying

Meat

> HEN

Size:	**Standard Cock.** 8.5 lb. (3.9 kg) / **Hen.** 6.5 lb. (3 kg). **Bantam Cock.** 34 oz. (965 g) / **Hen.** 30 oz. (850 g).
Notable Features:	Naked neck and vent (front of breast below neck); significantly reduced number of feathers on rest of body.
Place of Origin:	Eastern Europe (Hungary, Romania).
Conservation Status:	Study.
Special Qualities:	A good layer of medium to large, brown eggs, with a carcass that is easy to pluck.

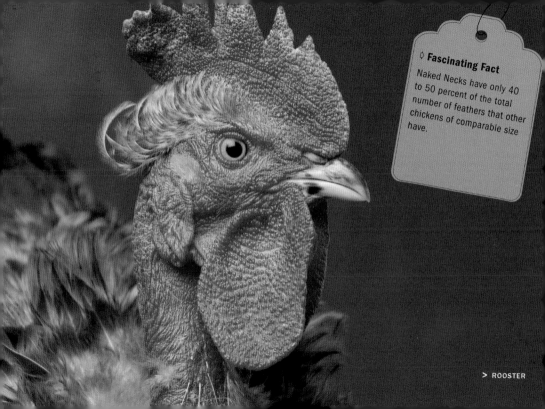

> ROOSTER

◊ Nankin

Considered to be one of the most ancient bantam breeds, the Nankin was first imported to the United States in the eighteenth century. Once quite popular and used to develop Sebright bantams, now it is extremely rare.

Ornamental

Laying

Meat

> HEN

Size:	**Cock.** 24 oz. (680 g) / **Hen.** 22 oz. (625 g).
Notable Features:	Primarily orangey red to golden buff plumage (darker and more lustrous in males). Black tail.
Place of Origin:	Southeast Asia.
Conservation Status:	Critical.
Special Qualities:	Very good brooder; lays small, creamy white eggs.

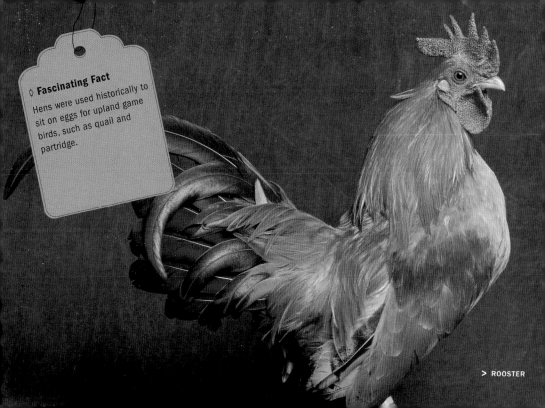

◇ **Fascinating Fact**
Hens were used historically to sit on eggs for upland game birds, such as quail and partridge.

> ROOSTER

◊ New Hampshire

This dual-purpose chicken, developed by New Hampshire researchers and farmers in the early years of the twentieth century, dresses out as a nice, plump broiler or a roaster.

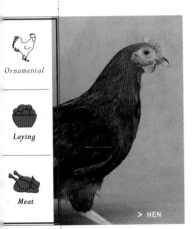

Ornamental

Laying

Meat

> HEN

Size: Standard Cock. 8.5 lb. (3.9 kg) / Hen. 6.5 lb. (3 kg). Bantam Cock. 34 oz. (965 g) / Hen. 30 oz. (850 g).

Notable Features: Bright red comb and wattles; bright red, elongated earlobes. Golden bay to chestnut red plumage.

Place of Origin: United States.

Conservation Status: Watch.

Special Qualities: Excellent dual-purpose bird where meat production is a primary consideration.

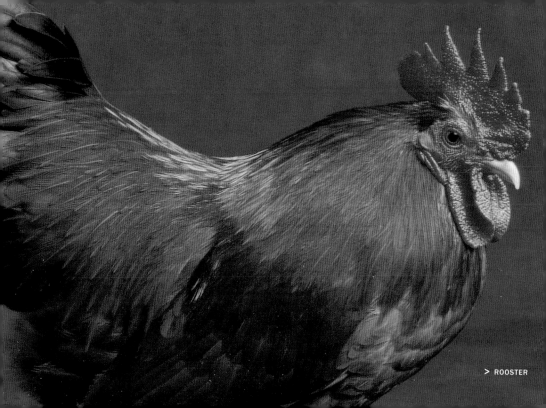

> ROOSTER

◊ Old English Game

Developed from English fighting birds after cockfighting was outlawed in England in 1849, these birds still have a feisty character that reflects their heritage. They are hardy, vigorous, active, and very noisy.

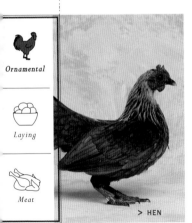

Ornamental

Laying

Meat

> HEN

Size:	**Standard Cock.** 5 lb. (2.25 kg) / **Hen.** 4 lb. (1.8 kg). **Bantam Cock.** 24 oz. (680 g) / **Hen.** 22 oz. (635 g).
Notable Features:	Relatively small body; tightly feathered plumage. More than 30 color varieties.
Place of Origin:	Britain.
Conservation Status:	Study.
Special Qualities:	Exceptionally hardy and vigorous; known for great longevity. Will easily revert to feral living.

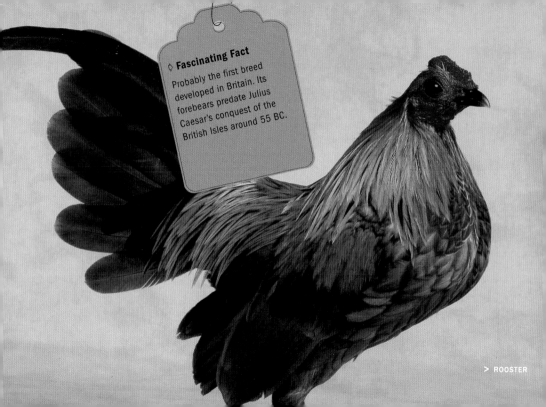

◊ **Fascinating Fact**

Probably the first breed developed in Britain. Its forebears predate Julius Caesar's conquest of the British Isles around 55 BC.

> ROOSTER

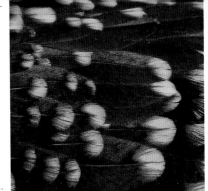

Old English Games are one of the most colorful breeds, with over 30 color varieties. A close-up of a Spangled hen is shown here.

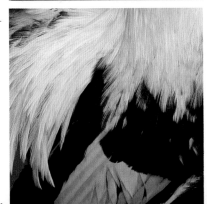

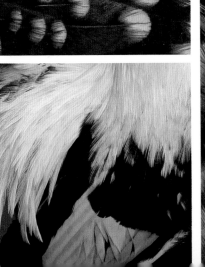

At right, a close-up of a Silver Duckwing rooster; at far right, the unique coloring of a Crele rooster.

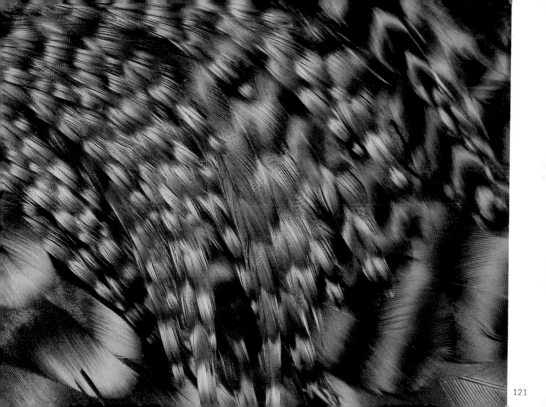

121

◊ **Orloff**

The Orloff is an ancient breed that developed in the Persian Gulf region and was widely dispersed by the sixteenth century. Though slow to mature, Orloffs are usually raised as meat birds. They are exceedingly hardy.

Ornamental

Laying

Meat

> HEN

Size:	**Standard Cock.** 8 lb. (3.6 kg) / **Hen.** 6.5 lb. (3 kg). **Bantam Cock.** 33 oz. (935 g) / **Hen.** 30 oz. (850 g).
Notable Features:	Small, bright red walnut comb set well forward on head. Fairly tall; large brow; beard and muffs. Color varieties are Black-Tailed Red, Spangled, and White.
Place of Origin:	Persia.
Conservation Status:	Critical.
Special Qualities:	Attractive birds for broiler production with very good eating quality, but slow growing.

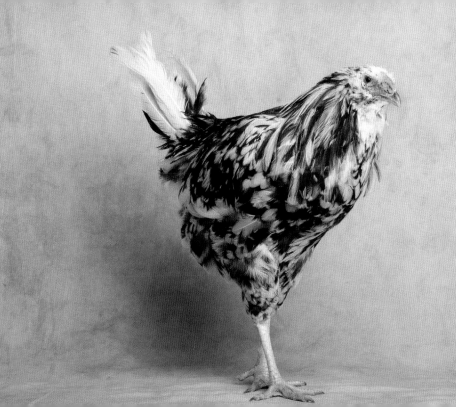

> ROOSTER

◊ Orpington

Winner of the grand prize cup at its debut in 1866 at the Crystal Palace Poultry Show in England, the Orpington is still a favorite of fanciers today. Orpingtons are docile and somewhat affectionate with their handlers.

Ornamental

Laying

Meat

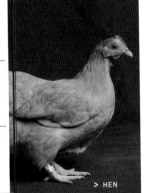

> HEN

Size: Standard Cock. 10 lb. (4.54 kg) / Hen. 8 lb. (3.5 kg). Bantam Cock. 38 oz. (1.1 kg) / Hen. 34 oz. (965 g).

Notable Features: Broad, full feathers lie smooth against body, giving a substantial appearance. Color varieties are Black, Blue, Buff, and White.

Place of Origin: England.

Conservation Status: Recovering.

Special Qualities: A good dual-purpose bird with a nice disposition. They are very cold hardy and mature quickly.

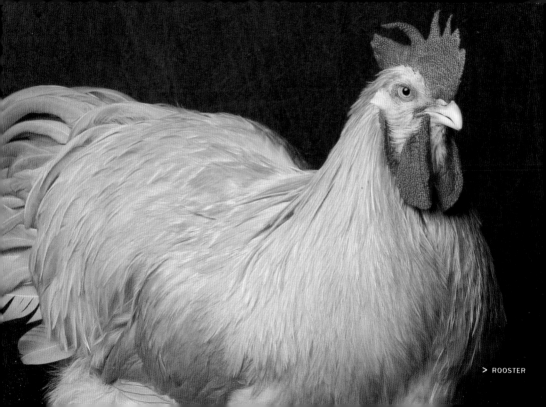

> ROOSTER

◊ Penedesenca

The Penedesenca was developed during the first half of the twentieth century in the Catalonian province of Spain. Its eggs are among the darkest of any chicken, and it produces high-quality meat for a layer breed.

Ornamental

Laying

Meat

> HEN

Size:	**Standard Cock.** 5.5 lb. (2.5 kg) / **Hen.** 4.5 lb. (2 kg).
Notable Features:	Bright red, unusual comb that begins like a large single but has multiple lobes at the rear.
Place of Origin:	Spain.
Conservation Status:	Not applicable.
Special Qualities:	Good layers, under free-range conditions, of very dark eggs (eggs of pullets are nearly black).

> ROOSTER

◊ Fascinating Fact

The Penedesenca almost died out, but a Spanish biologist saved it in the 1980s. Since then it has made a strong comeback, thanks in part to breeders interested in dark eggs.

◊ Phoenix

This breed was developed in the late 1800s in Germany by crossing Japanese long-tailed birds, called Onagadori, with game birds. Phoenixes must have high perches and tight, dry, well-bedded quarters to maintain feather quality.

Ornamental

Laying

Meat

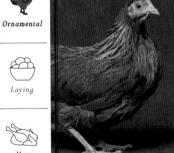

> HEN

Size:	**Standard Cock.** 5.5 lb. (2.5 kg) / **Hen.** 4 lb. (1.8 kg). **Bantam Cock.** 26 oz. (740 g) / **Hen.** 24 oz. (680 g).
Notable Features:	Horn beak; reddish bay eyes; leaden blue shanks and toes. Roosters have an extraordinarily long tail.
Place of Origin:	Germany.
Conservation Status:	Study.
Special Qualities:	Small, highly ornamental bird.

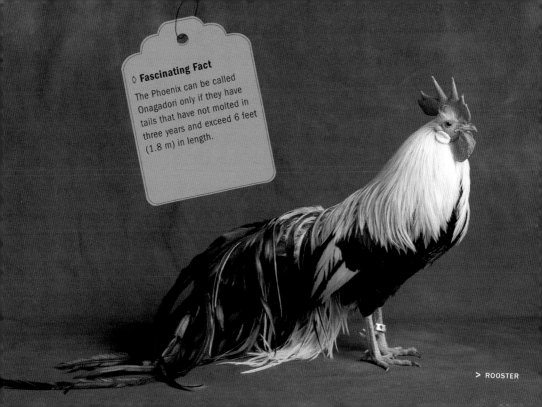

◊ Fascinating Fact

The Phoenix can be called
Onagadori only if they have
tails that have not molted in
three years and exceed 6 feet
(1.8 m) in length.

> ROOSTER

The exquisite feathering
of a Golden Phoenix rooster.

◊ Plymouth Rock

With its dual-purpose traits, hardiness, and docile disposition, the Plymouth Rock was the most common bird in America at the end of the nineteenth and the beginning of the twentieth centuries.

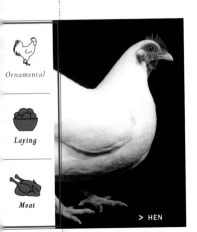

Ornamental

Laying

Meat

> HEN

Size: Standard Cock. 9.5 lb. (4.3 kg) / Hen. 7.5 lb. (3.4 kg). Bantam Cock. 36 oz. (1 kg) / Hen. 32 oz. (910 g).

Notable Features: Bright red single comb with five serrated points. Bright red wattles and earlobes.

Place of Origin: United States.

Conservation Status: Recovering.

Special Qualities: Very cold-hardy, friendly, and adaptable to either confinement or free range.

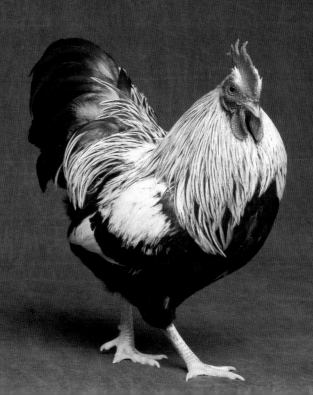

◊ **Polish**

With their wild crest feathers and sprightly behavior, Polish chickens can be comic entertainers. Polish hens were originally developed as a layer breed, and many varieties are still excellent layers.

Ornamental

Laying

Meat

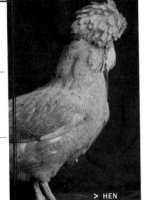

> HEN

Size: **Standard Cock.** 6 lb. (2.75 kg) / **Hen.** 4.5 lb. (2 kg). **Bantam Cock.** 30 oz. (850 g) / **Hen.** 26 oz. (740 g).

Notable Features: Small, bright red, V-shaped comb. Prominent crest feathers; some varieties have a beard and muffs.

Place of Origin: Holland.

Conservation Status: Watch.

Special Qualities: May spook if their crest interferes with their vision and they suddenly realize something is near.

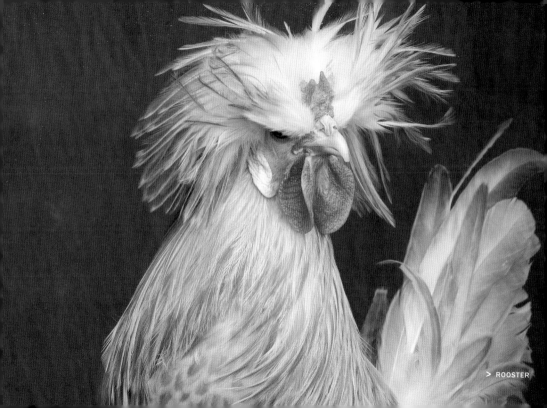

> ROOSTER

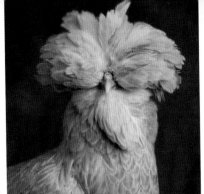

A Polish hen with a beard and muff.

The Polish's wild crest feathers, as seen on this White-Crested Black hen (right) and White-Crested Black rooster (far right), can interfere with its vision.

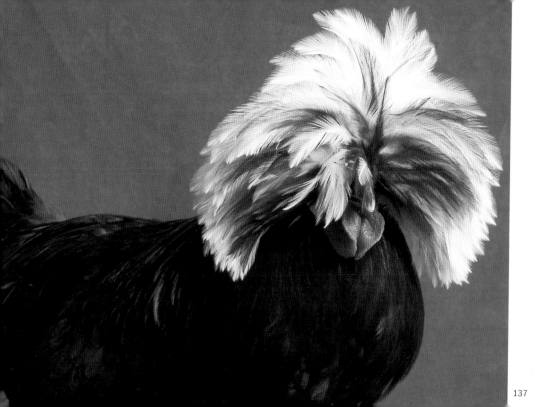

◊ Redcap

Hardy, long-lived birds, Redcaps are quite active and alert. The breed is known for the size and prominence of its large, pebbled rose comb, which is much bigger than other rose-comb breeds, such as the Hamburg.

Ornamental

Laying

Meat

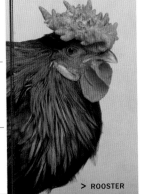

> ROOSTER

Size: **Standard Cock.** 7.5 lb. (3.4 kg) / **Hen.** 6 lb. (2.75 kg). **Bantam Cock.** 30 oz. (850 g) / **Hen.** 26 oz. (740 g).

Notable Features: Bright red, very large rose comb. Red earlobes with a white center.

Place of Origin: England.

Conservation Status: Critical.

Special Qualities: Truly an excellent layer for free range, with a stunning rose comb.

138

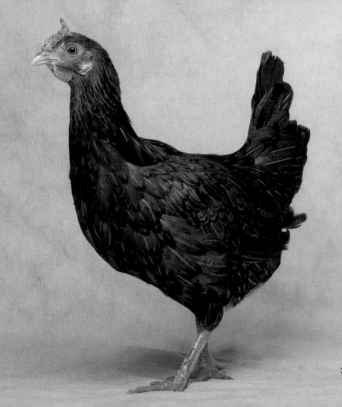

> HEN

◊ Rhode Island Red

The state bird of Rhode Island, the Rhode Island Red is one of the best dual-purpose breeds and a super choice for backyard flocks. The birds are hardy and do well on a free-range operation, though they will tolerate confinement.

Ornamental

Laying

Meat

> HEN

Size: Standard Cock. 8.5 lb. (3.9 kg) / Hen. 6.5 lb. (3 kg). Bantam Cock. 34 oz. (965 g) / Hen. 30 oz. (850 g).

Notable Features: Bright red single comb has five upright, evenly serrated points. Primarily dark red plumage; mainly black tail.

Place of Origin: United States.

Conservation Status: Recovering.

Special Qualities: Excellent layer of large brown eggs, but also a fine eating bird. Hardy, early to mature, and usually calm.

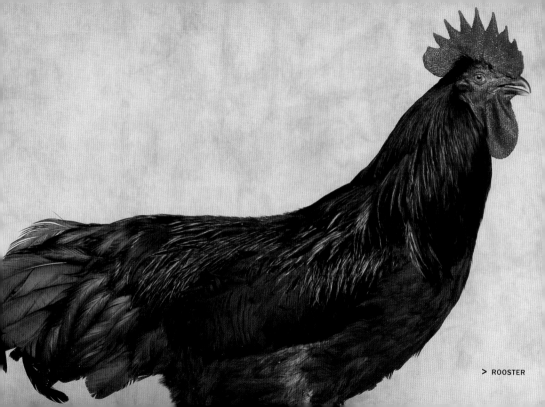

> ROOSTER

◊ Rhode Island White

The Rhode Island White is a separate breed from the Rhode Island Red. The White has never enjoyed the same popularity as the Red, though it is also a good barnyard bird, with a mellow disposition and early maturation.

Ornamental

Laying

Meat

Size: **Standard Cock.** 8.5 lb. (3.9 kg) / **Hen.** 6.5 lb. (3 kg).
Bantam Cock. 34 oz. (965 g) / **Hen.** 30 oz. (850 g).

Notable Features: Bright red, medium-size rose comb, wattles, and earlobes. Yellow beak; reddish bay eyes; yellow shanks and toes.

Place of Origin: United States.

Conservation Status: Watch.

Special Qualities: Great dual-purpose bird for barnyard or backyard. Cold-hardy, friendly, and adaptable to either confinement or free range.

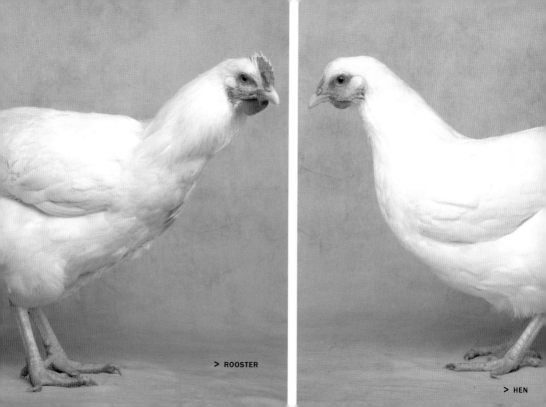

> ROOSTER

> HEN

◊ Rosecomb

A breed of ancient origins, Rosecombs are a darling of breeders who keep them. They do well on the show circuit, but they are challenging to raise. Some breeders report poor fertility and hatchability.

Ornamental

Laying

Meat

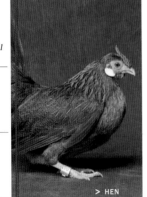

> HEN

Size:	**Cock.** 26 oz. (740 g) / **Hen.** 22 oz. (625 g).
Notable Features:	Large, bright red rose comb; well-rounded, fairly prominent white earlobes; large, full tail. More than 20 color varieties.
Place of Origin:	Britain.
Conservation Status:	Not applicable.
Special Qualities:	Particularly decorative bantam for the serious fancier.

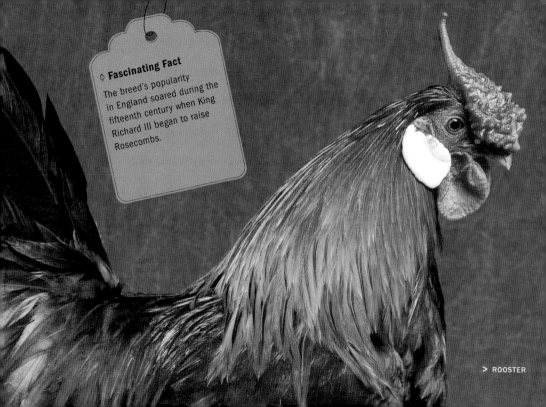

◇ **Fascinating Fact**

The breed's popularity in England soared during the fifteenth century when King Richard III began to raise Rosecombs.

> ROOSTER

◊ Sebright

Developed from Polish and Nankins by Sir John Sebright, the Sebright has some unusual coloring on the head. Like Rosecombs, Sebrights are best-suited for experienced breeders.

Ornamental

Laying

Meat

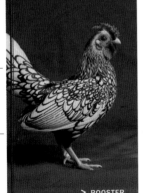

> ROOSTER

Size:	**Cock.** 22 oz. (625 g) / **Hen.** 20 oz. (570 g).
Notable Features:	Medium-size rose comb, purplish red in males, gray to dark plum in females. Purplish red or turquoise earlobes. Males lack long tail feathers and pointed hackle and saddle feathers.
Place of Origin:	Britain.
Conservation Status:	Study.
Special Qualities:	A unique-looking true bantam.

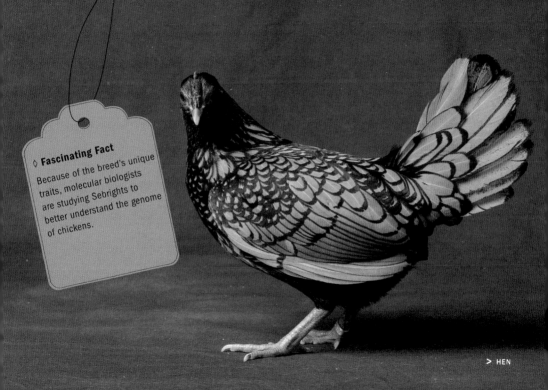

◊ **Fascinating Fact**

Because of the breed's unique traits, molecular biologists are studying Sebrights to better understand the genome of chickens.

> HEN

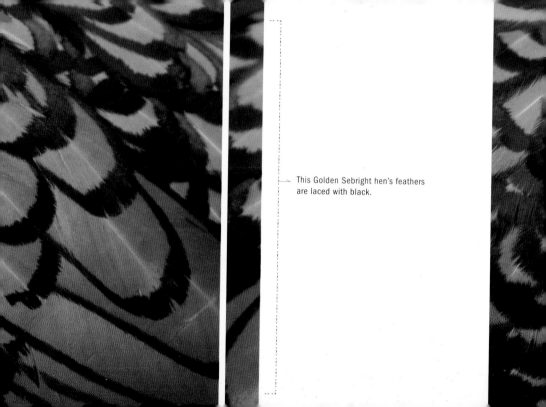

This Golden Sebright hen's feathers are laced with black.

◊ Serama

The smallest breed in the world, mature Serama cocks weigh as little as 12 ounces (340 g) and may stand a mere 6 inches (15.25 cm) off the floor. Though very friendly and enchanting, they are challenging to rear.

Ornamental

Laying

Meat

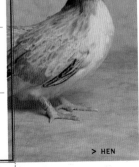

> HEN

Size: **Class A Cock.** 12 oz. (340 g) / **Hen.** 11 oz. (312 g). **Class B Cock.** 17 oz. (482 g) / **Hen.** 15 oz. (425 g). **Class C Cock.** 20 oz. (570 g)/ **Hen.** 17 oz. (482 g).

Notable Features: Broad, chesty build; long, full tail; long wings held toward the ground. They can appear in almost any color.

Place of Origin: Malaysia.

Conservation Status: Not applicable.

Special Qualities: Eggs hatch best when brooded naturally by other breeds.

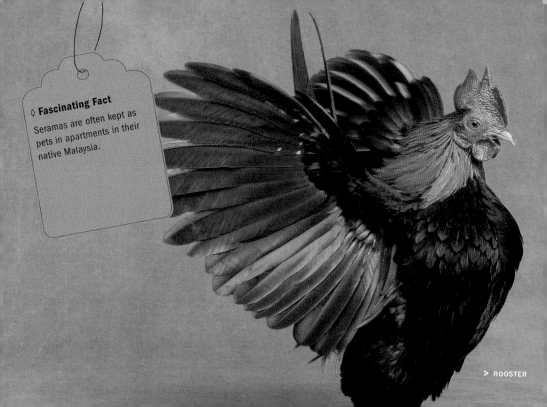

◇ Fascinating Fact

Seramas are often kept as pets in apartments in their native Malaysia.

> ROOSTER

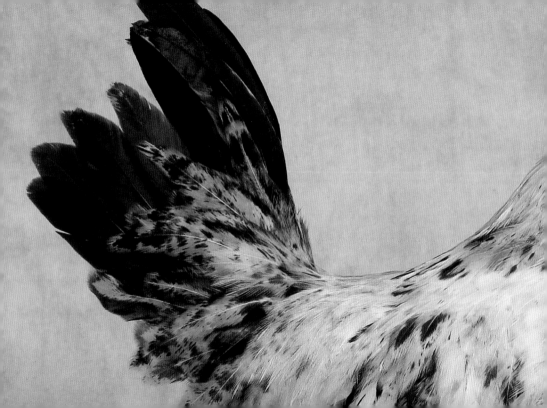

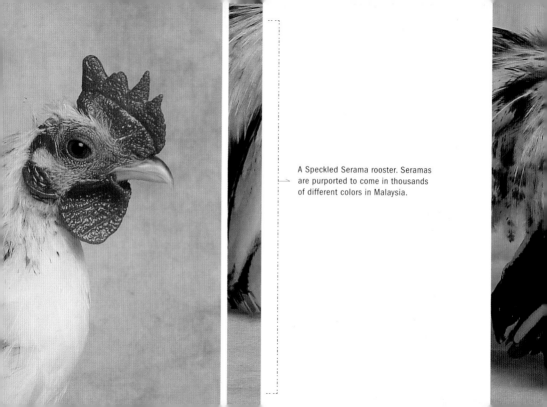

A Speckled Serama rooster. Seramas are purported to come in thousands of different colors in Malaysia.

⇨ Shamo

Measuring about 30 inches (76 cm) tall, the Shamo is the second tallest chicken breed. It is an ancient Japanese breed from which a number of other domesticated Japanese chickens were developed, including the Phoenix.

Ornamental

Laying

Meat

Size:	**Standard Cock.** 11 lb. (5 kg) / **Hen.** 7 lb. (3.2 kg). **Bantam Cock.** 44 oz. (1.25 kg) / **Hen.** 35 oz. (990 g).
Notable Features:	Short, hard feathers may not fully cover body; prominent, bony forehead; no feathers on face and throat.
Place of Origin:	Japan.
Conservation Status:	Study.
Special Qualities:	Upright birds that are making a name with show enthusiasts. Hens lay more eggs than other Asiatic game birds.

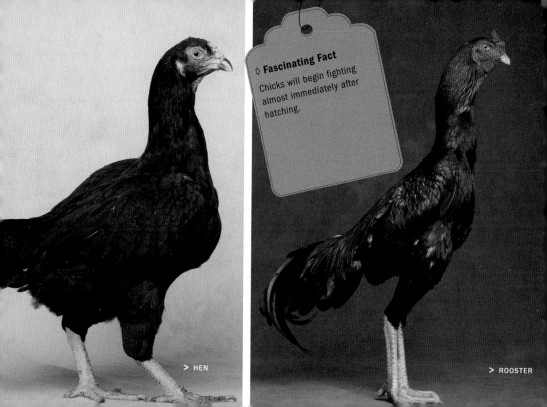

◇ **Fascinating Fact**

Chicks will begin fighting almost immediately after hatching.

> HEN

> ROOSTER

◊ Sicilian Buttercup

This breed is named for its cup-shaped comb, which looks like a crown, and the hen's buttery golden base color. The Sicilian Buttercup was found on the island of Sicily. Some poultry historians think its roots date back to biblical times.

Ornamental

Laying

Meat

> ROOSTER

Size:	**Standard Cock.** 6.5 lb. (3 kg) / **Hen.** 5 lb. (2.25 kg). **Bantam Cock.** 26 oz. (740 g) / **Hen.** 22 oz. (625 g).
Notable Features:	Red, cup-shaped comb. Unlike most chicken breeds, female plumage is more striking than male plumage.
Place of Origin:	Italy.
Conservation Status:	Critical.
Special Qualities:	Beautiful and a decent layer of small to medium-size, white eggs.

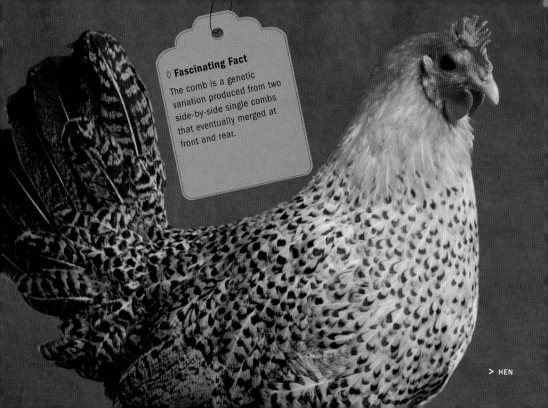

> HEN

◊ Silkie

An ancient breed of Asian derivation, the Silkie is truly a one-of-a-kind breed. Silkies have a melanotic gene that results in bluish black skin, beaks, bones, and meat, plus turquoise earlobes and silky-soft feathers.

Ornamental

Laying

Meat

Size: **Cock.** 36 oz. (1 kg) / **Hen.** 32 oz. (910 g).

Notable Features: Small to medium, deep mulberry walnut comb and wattles; small, turquoise blue earlobes. Leaden blue beak; black eyes; bluish black shanks and toes.

Place of Origin: Asia.

Conservation Status: Not applicable.

Special Qualities: Ideal as a pet chicken; excellent broody hen that will raise chicks from other species. The male and female look virtually identical.

> HEN

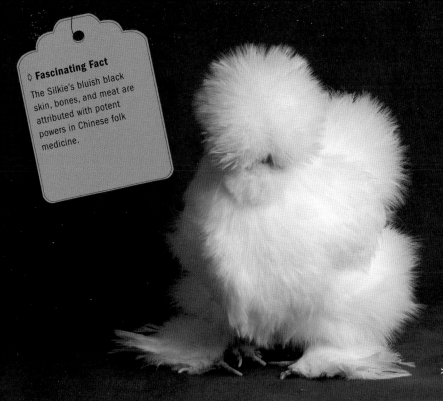

The Silkie's bluish black skin, bones, and meat are attributed with potent powers in Chinese folk medicine.

> HEN

◊ Sultan

Called Serai-Tavuk ("fowls of the sultan") in its native Turkey, the Sultan was indeed kept by Turkish royalty for centuries as a pet and as a living garden ornament. Calm, easy to handle, and well suited for close confinement, it is a good backyard bird.

Ornamental

Laying

Meat

Size:	**Standard Cock.** 6 lb. (2.75 kg) / **Hen.** 4 lb. (1.8 kg). **Bantam Cock.** 26 oz. (740 g) / **Hen.** 22 oz. (625 g).
Notable Features:	Very small, bright red, V-shaped comb. Relatively small body; crest; beard and muffs; well-feathered legs; vulture hocks.
Place of Origin:	Turkey.
Conservation Status:	Study.
Special Qualities:	A small, regal bird that makes a good pet. Requires a tight, dry coop to keep feathers in good shape. The male and female look virtually identical.

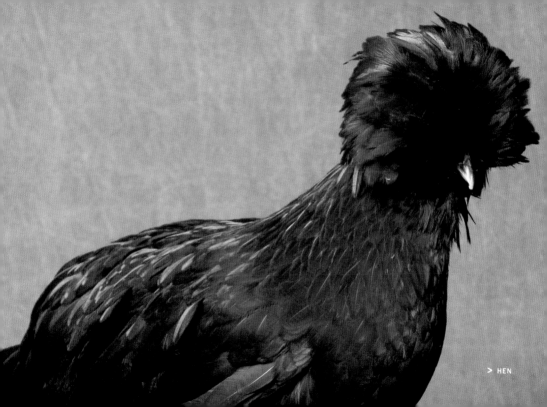

> HEN

◇ Sumatra

An ancient and primitive breed, the Sumatra is reputed to be one of the best fliers in chickendom. It is extraordinarily stylish, with some of the most lustrous plumage of any breed, and is known for a spry strut and swagger.

Ornamental

Laying

Meat

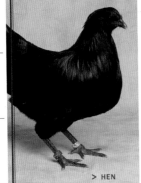

> HEN

Size: **Standard Cock.** 5 lb. (2.25 kg) / **Hen.** 4 lb. (1.8 kg). **Bantam Cock.** 24 oz. (680 g) / **Hen.** 22 oz. (625 g).

Notable Features: Lustrous plumage; long, flowing, horizontal tail; gray to dark plum face; glossy black legs.

Place of Origin: Sumatra.

Conservation Status: Critical.

Special Qualities: Cocks frequently have a cluster of several spurs on each leg, which is unique to the breed.

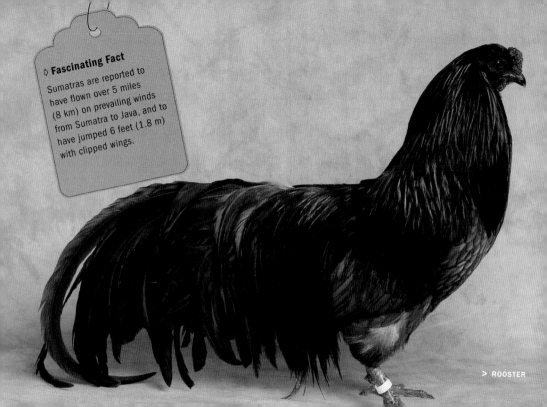

> ROOSTER

◊ **Sussex**

Probably the most common utility breed for almost a century in England, the Sussex provided meat and eggs from the midnineteenth to the midtwentieth centuries. It was never as popular in North America.

Ornamental

Laying

Meat

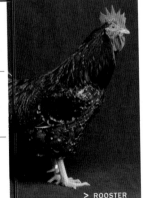

> ROOSTER

Size:	**Standard Cock.** 9 lb. (4.1 kg) / **Hen.** 7 lb. (3.2 kg). **Bantam Cock.** 36 oz. (1 kg) / **Hen.** 32 oz. (910 g).
Notable Features:	Long, broad back. Colors are Birchen, Buff, Dark Brown, Light, Red, Speckled, and White.
Place of Origin:	England.
Conservation Status:	Threatened.
Special Qualities:	Great dual-purpose bird. Calm and curious, does well in confinement and free range.

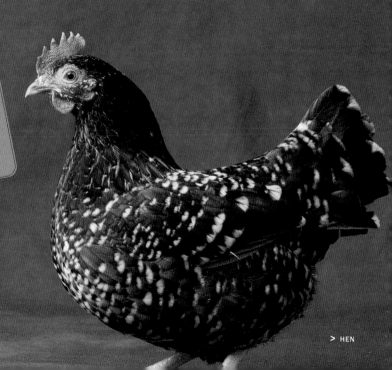

◊ **Fascinating Fact**

The Sussex and the Dorking may have once been the same breed, with five-toed offspring being Dorkings and four-toed being Sussex.

> HEN

◊ Vorwerk Bantam

This breed was developed in 1966 by Minnesotan Wilmar Vorwerk and is based on an older German breed developed by Oscar Vorwerk. Vorwerk Bantams are active, alert birds with an upright carriage and a full tail.

Ornamental

Laying

Meat

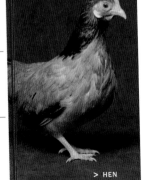

> HEN

Size: **Cock.** 27 oz. (765 g) / **Hen.** 23 oz. (652 g).

Notable Features: Bluish gray to horn beak; orangey red eyes with yellow iris; slate shanks and toes. Upright carriage and full tail.

Place of Origin: United States.

Conservation Status: Not applicable.

Special Qualities: A good dual-purpose bantam with a nice disposition for backyard and barnyard flocks.

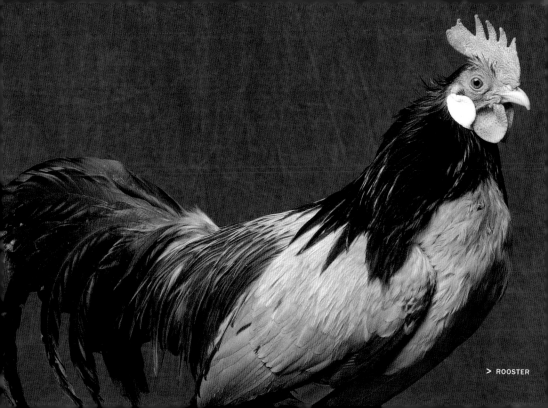

> ROOSTER

◊ Welsummer

A relatively new breed to North America, the Welsummer takes its name from the village of Welsum, Holland. Welsummers are purported to be one of the top free-range foragers of all the layers.

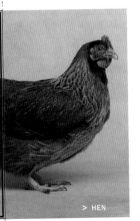

> HEN

Ornamental

Laying

Meat

Size: **Standard Cock.** 7 lb. (3.2 kg) / **Hen.** 6 lb. (2.75 kg). **Bantam Cock.** 34 oz. (965 g) / **Hen.** 30 oz. (850 g).

Notable Features: Dark horn beak; reddish bay eyes; yellow shanks and toes.

Conservation Status: Not applicable.

Place of Origin: Holland.

Special Qualities: Lays beautiful eggs of a dark and deep reddish brown. Excellent forager.

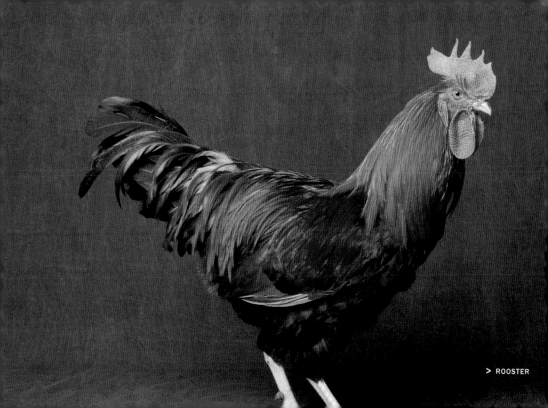

◇ White-Faced Spanish

The White-Faced Spanish is considered one of the oldest Mediterranean breeds, and one of the oldest breeds in the United States. White-Faced Spanish birds take more than a year to develop. They are also active and noisy.

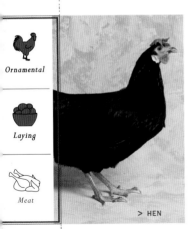

Ornamental

Laying

Meat

> HEN

Size: Standard Cock. 8 lb. (3.6 kg) / **Hen.** 6.5 lb. (3 kg). **Bantam Cock.** 30 oz. (850 g) / **Hen.** 26 oz. (740 g).

Notable Features: Bright red single comb with five points; upright in male, droops to side in female. Long, thin, bright red wattles. Large, enamel white earlobes.

Place of Origin: Spain.

Conservation Status: Critical.

Special Qualities: A good laying breed; unusual coloring.

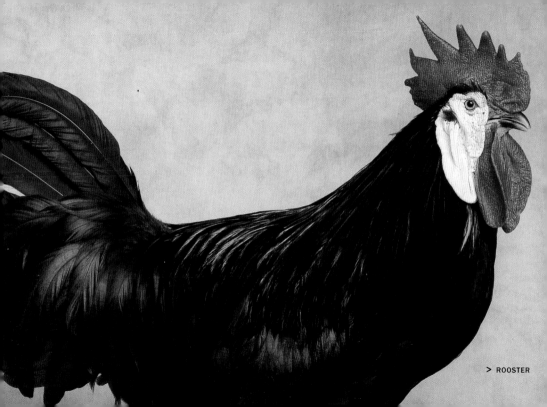

> ROOSTER

◊ Wyandotte

A showy bird that has a loyal following, Wyandottes are also superb dual-purpose birds that mature fairly quickly and have good egg production. A dressed Wyandotte is nearly proportional to a Cornish–Plymouth Rock cross.

Ornamental

Laying

Meat

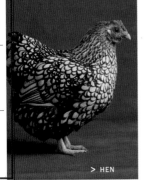

> HEN

Size: Standard Cock. 8.5 lb. (3.9 kg) / **Hen.** 6.5 lb. (3 kg) **Bantam Cock.** 30 oz. (850 g) / **Hen.** 26 oz. (740 g).

Notable Features: Well-rounded body; stout legs set wide apart; short tail; loose, fluffy feathers. Wide range of fancy colors.

Place of Origin: United States.

Conservation Status: Recovering.

Special Qualities: A workhorse of a dual-purpose breed that is extremely cold hardy and also is a crowd-pleaser on the show circuit.

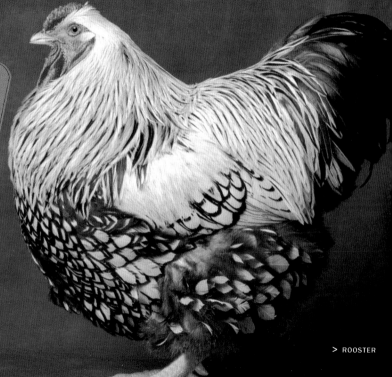

> ROOSTER

A Blue-Laced Red Wyandotte hen — an unusual color in chickendom.

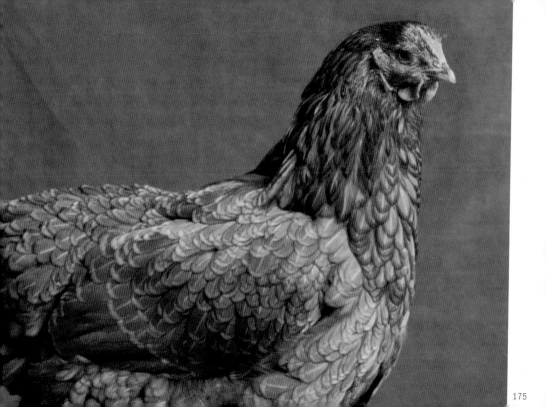

DUCKS

◊ Ancona

Anconas are best known for their spots, which come in a number of color combinations, such as black and white, chocolate and white, and lavender and white.

Ducks

Size:	Medium class (7–8 lb. [3.2–3.6 kg]).
Notable Features:	White with patches of color, such as black, blue, or chocolate.
Place of Origin:	England.
Conservation Status:	Critical.
Special Qualities:	Good layers with a long productive season. Excellent foragers and less vulnerable to predation than some other ducks.

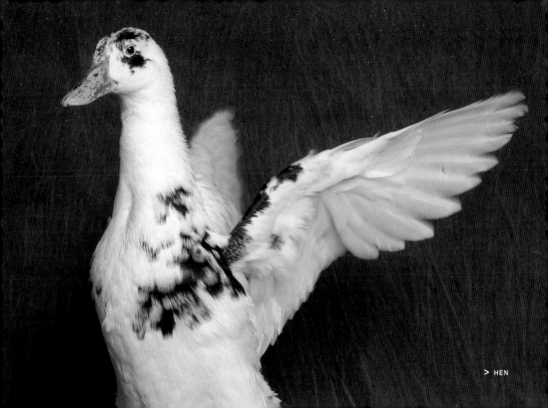

> HEN

◊ Australian Spotted

Also called "Spots," Australian Spotted ducks are long-lived, personable ducks that are exceptionally hardy, have outstanding foraging abilities, and are the best layers of the bantam breeds. They are known for having a racy, teardrop-shaped body.

Ducks

Size:	Bantam class (40 oz. [1.13 kg] or less).
Notable Features:	Racy, teardrop-shaped body. Three varieties: Greenhead (the foundation variety), Bluehead (shown right), and Silverhead.
Place of Origin:	United States.
Conservation Status:	Study.
Special Qualities:	They have a voracious appetite for insects and are often kept as a pest-control squad. Good fliers.

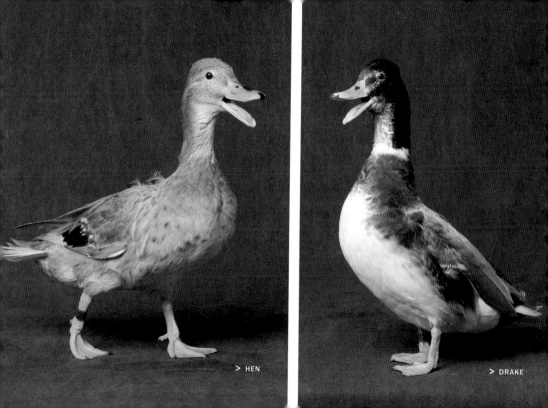

> HEN

> DRAKE

◊ Buff

**Developed by William Cook, also the breeder of the
Orpington chicken, the Buff is raised frequently by fanciers
for show purposes, though it shouldn't be discounted
as a practical backyard or barnyard bird. It yields a fine
medium-size roaster.**

Ducks

Size: Medium class (7–8 lb. [3.2–3.6 kg]).

Notable Features: Both hen and drake have primarily fawn-brown plumage; drake has rich fawn-buff to seal-brown head and upper neck.

Place of Origin: England.

Conservation Status: Threatened.

Special Qualities: Friendly and fairly docile. Good roaster; hens are good layers of medium-size white or lightly tinted eggs.

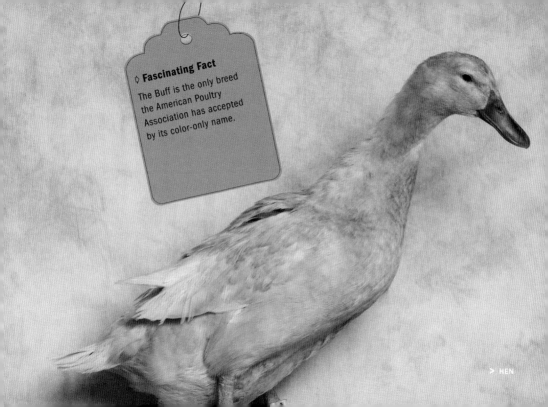

> HEN

◇ Call

The cutest of all ducks, Calls have a tiny beak, large eyes, and a stubby neck set atop a squat, rounded body. They make excellent pets, with their extrafriendly disposition, though they are very noisy.

Ducks

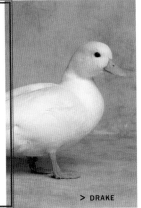

> DRAKE

Size:	Bantam class (40 oz. [1.1 kg] or less).
Notable Features:	Small beak; large eyes. Interesting color varieties, such as Blue, Gray, Pastel, and Snowy.
Place of Origin:	Northern Europe.
Conservation Status:	Not applicable.
Special Qualities:	Raised primarily as show birds.

> HEN

◊ Campbell

Mrs. Adele Campbell developed the Campbell in England during the late 1800s. She bred a single Penciled Runner that was a prolific layer to a Rouen to increase its size, and later used a Mallard to increase hardiness and foraging ability.

Ducks

Size:	Light class (4–5 lb. [1.8–2.25 kg]).
Notable Features:	Dark tan body of Khaki variety reminded Adele Campbell of British military uniforms.
Place of Origin:	England.
Conservation Status:	Watch.
Special Qualities:	Good-sized carcass for production and excellent layer.

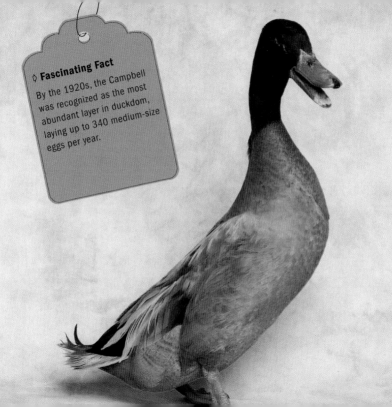

◇ **Fascinating Fact**

By the 1920s, the Campbell was recognized as the most abundant layer in duckdom, laying up to 340 medium-size eggs per year.

> DRAKE

◊ Dutch Hookbill

An old breed that has been documented in the
Netherlands and Germany since the seventeenth century,
the Dutch Hookbill is about the size and stature of a large
Mallard. It is quite rare.

Ducks

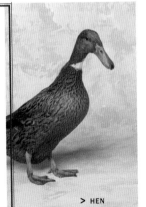

> HEN

Size:	Light (4–5 lb. [1.8 kg–2.25 kg]).
Notable Features:	Hooked bill curves from forehead and reminds some of a "Roman nose."
Place of Origin:	Netherlands and Germany.
Conservation Status:	Not applicable.
Special Qualities:	Very active. Hens lay lots of blue eggs; eggs do poorly when artificially incubated.

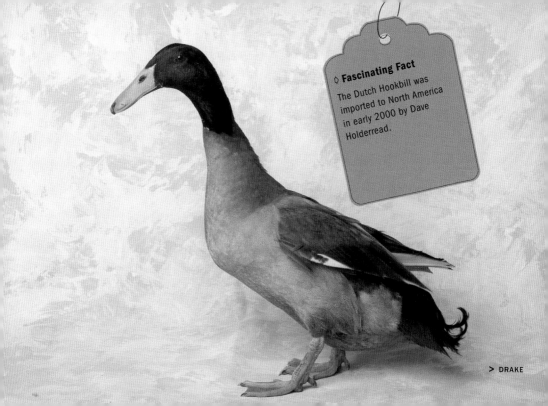

> DRAKE

◊ East Indies

Though small like a Call, the East Indies duck's body shape is similar to that of the Mallard. Birds are generally shyer and quieter than Calls, making them good pets, and they are popular with fanciers for showing.

Ducks

Size: Bantam class (40 oz. [1.13 kg] or less).

Notable Features: Black bill; dark brown eyes; black to dusky black shanks and feet lustrous greenish black plumage throughout.

Place of Origin: North America.

Conservation Status: Not applicable.

Special Qualities: Very good flier.

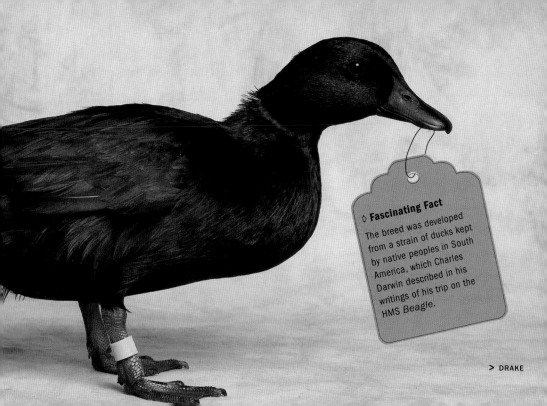

◊ **Fascinating Fact**

The breed was developed from a strain of ducks kept by native peoples in South America, which Charles Darwin described in his writings of his trip on the HMS Beagle.

> DRAKE

◊ Golden Cascade

A new breed, the Golden Cascade was developed in 1979 by Dave Holderread. Known as a dual-purpose breed for both meat and eggs, the Golden Cascade is also a lovely bird for ornamental purposes.

Ducks

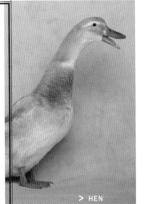

> HEN

Size: Medium class (7–8 lb. [3.2 kg– 3.6 kg]).

Notable Features: Drake has greenish bronze head, neck, and lower back; reddish brown breast; pale cream body. Hen has primarily rich fawn-buff plumage.

Place of Origin: United States.

Conservation Status: Not applicable.

Special Qualities: Fast growing; active forager with excellent laying ability. Crosses of the drake with females of any breed produce males and females that are different colors.

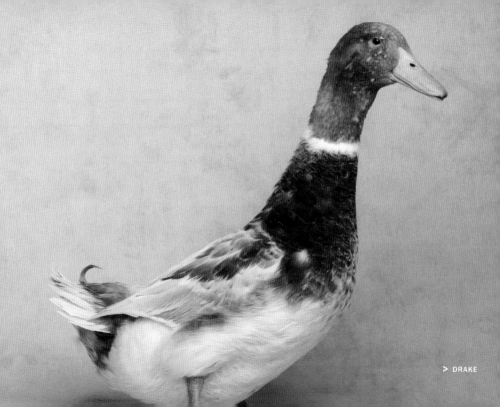

> DRAKE

◊ Muscovy

As domestic ducks go, the Muscovy is an odd duck. It is descended from the wild Muscovy, a native duck of South and Central America that does not migrate and is able to perch and nest in trees, thanks to its sharp toenails.

Ducks

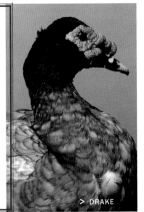

> DRAKE

Size: Heavy class (9 lb. [4.1 kg] or more).

Notable Features: Lumpy red skin about face (caruncles) in mature birds. There are four color varieties: Black, Blue, Chocolate, and White.

Place of Origin: South and Central America.

Conservation Status: Not applicable.

Special Qualities: Great for pest control. Quiet and personable. Very large and raised for meat.

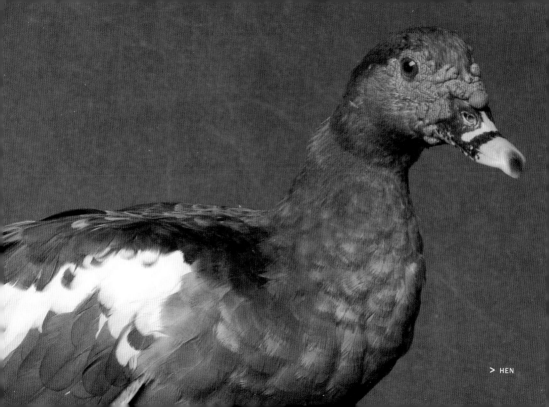

> HEN

◊ Pekin

Although the commercial duck sector is much smaller than the poultry industry in North America, the Pekin is to ducks what the Cornish–Plymouth Rock cross is to chickens. They have fast growth, good feed conversion, and a carcass that is easy to clean.

Ducks

Size: Heavy class (9 lb. [4.1 kg] or more).

Notable Features: Yellow bill; deep leaden blue eyes; light orange shanks and feet. Looser, fluffier feathers than other ducks.

Place of Origin: China.

Conservation Status: Not applicable.

Special Qualities: Gregarious and talkative; good pets. Good layers, but require incubator.

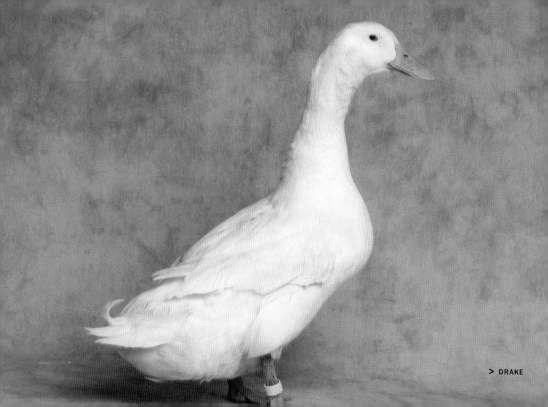

> DRAKE

◊ Rouen

Developed in France hundreds of years ago as a table bird, the Rouen we know today was greatly influenced by the English, who increased its weight, changed its shape, and improved its colors. The Rouen is popular with fanciers.

Ducks

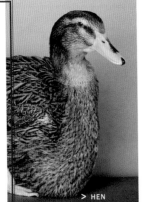

> HEN

Size:	Heavy class (9 lb. [4.1 kg] or more).
Notable Features:	Very deep keep on Standard-bred birds.
Place of Origin:	France.
Conservation Status:	Watch.
Special Qualities:	Production-type Rouens are good foragers with a calm disposition. Standard-bred Rouen males may have fertility problems. Both types produce excellent-quality meat.

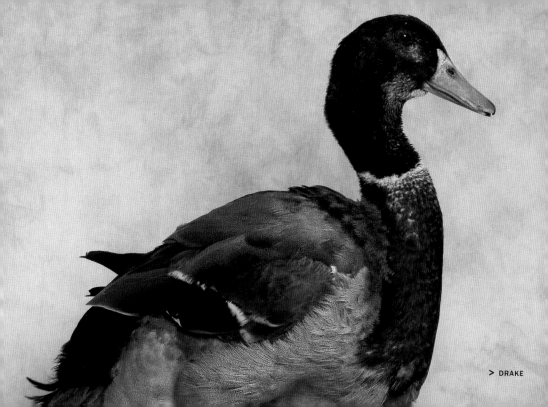

> DRAKE

◊ Runner

Sometimes referred to as Indian Runner ducks or "penguin ducks," Runners are among the most energetic members of duckdom, constantly on the move. The ducks are prolific layers, outperforming many chickens.

Ducks

Size: Light class (4–5 lb. [1.8–2.25 kg]).

Notable Features: Tall, thin, upright stature. Many color varieties.

Place of Origin: Indonesia.

Conservation Status: Watch.

Special Qualities: Great pets and excellent exhibition birds.

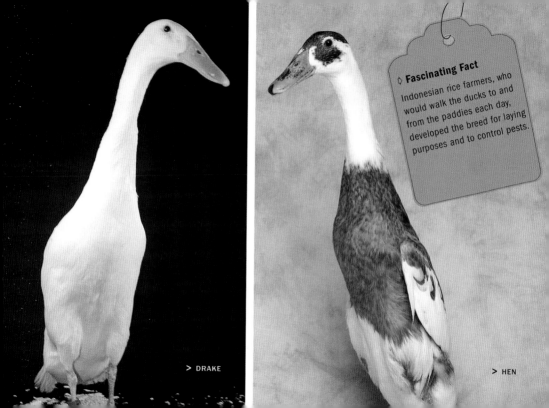

> DRAKE

> HEN

◊ Saxony

A good all-purpose breed, Saxony ducks are excellent layers and mothers, and the meat from the bird is flavorful yet not very greasy. They are active foragers and hardy birds, adapting well to various environments.

Ducks

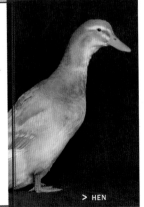

> HEN

Size: Heavy class (9 lb. [4.1 kg] or more).

Notable Features: Drake has powder blue head and neck; claret breast; oatmeal body and wings. Hen has fawn-buff plumage.

Place of Origin: Germany.

Conservation Status: Critical.

Special Qualities: Hens lay 200 or more large white eggs per year. Produces a good carcass of flavorful meat that isn't greasy.

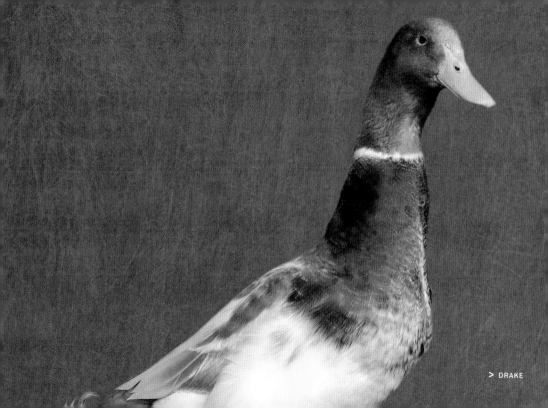

> DRAKE

◊ Swedish

Also known as the Blue Swedish, this breed is slow to mature but is a good meat-type duck and a reasonable layer. Blue ducks have been bred for centuries in northern Europe and are quite hardy.

Ducks

Size: Medium class (7–8 lb. [3.2 kg–3.6 kg]).

Notable Features: Greenish blue bill in males, bluish slate bill in females. Primarily uniform bluish slate plumage, with white, heart-shaped bib on breast.

Place of Origin: Northern Europe.

Conservation Status: Watch.

Special Qualities: Good dual-purpose duck. It doesn't breed true 100 percent of the time: about 25 percent of offspring will be Black; 25 percent will be White, Silver, or Splashed; the remainder will be Blue.

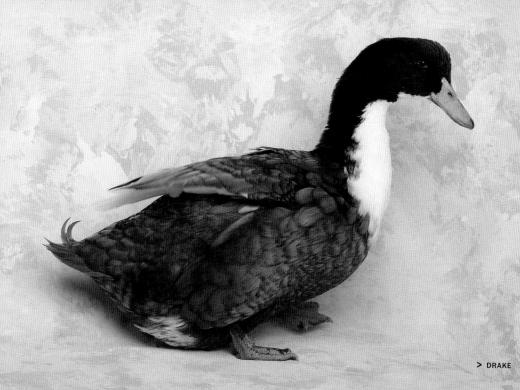

> DRAKE

◊ Welsh Harlequin

Bred from Khaki Campbells that showed an unusual color mutation, Welsh Harlequins are fine utility birds. They produce lean meat on an easy-to-clean carcass, and ducks are abundant layers and excellent mothers.

Ducks

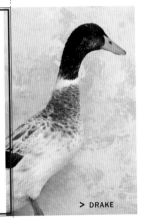

> DRAKE

Size:	Light class (4–5 lb. [1.8–2.25 kg]).
Notable Features:	Green to greenish black bill. Hen has lovely dark brown, fawn, and white plumage.
Place of Origin:	Wales.
Conservation Status:	Critical.
Special Qualities:	Active foragers, though more vulnerable to predators than darker-colored breeds.

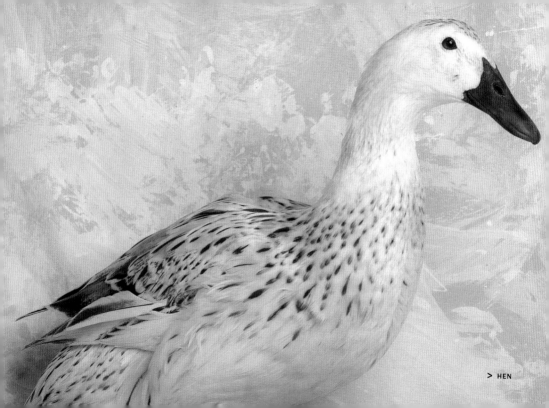

> HEN

GEESE

◊ African

The African is considered by some people to be one of the gentlest breeds of domestic geese. It talks a lot, though it is not extremely loud. The African is cold-hardy and produces a good carcass with tasty, lean meat.

Geese

Size: Heavy class (22 lb. [10 kg] or more).

Notable Features: Large dewlap; knob over back part of bill, in front of eye.

Place of Origin: Unknown.

Conservation Status: Watch.

Special Qualities: It has an unusual sound that is more like a "doink" than a "honk."

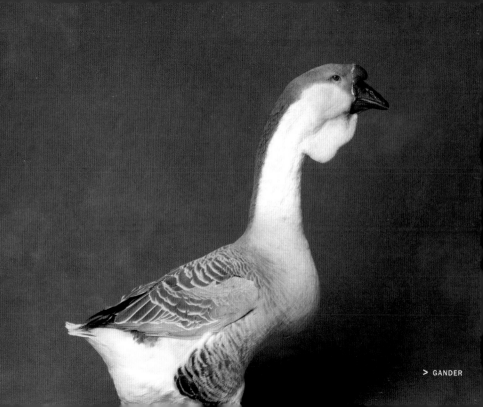

◊ American Buff

The largest of the medium-size geese, American Buffs make fine roasting birds that are easily prepared thanks to light-colored pinfeathers that allow them to dress out as cleanly as white geese. American Buffs are docile and make excellent parents.

Geese

Size:	Medium class (14–21 lb. [6.4–9.5 kg]).
Notable Features:	Orange beak, shanks, and feet; light yellowish buff plumage laced with white; pure white underbelly.
Place of Origin:	United States.
Conservation Status:	Critical.
Special Qualities:	A fine roasting bird.

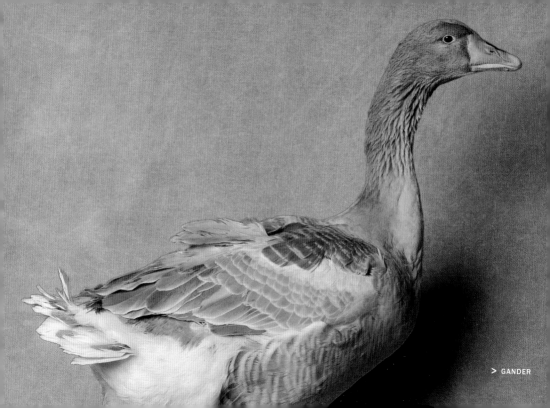

> GANDER

◊ Chinese

Though lightweight, Chinese are tall, lithe, and graceful birds. Chinese geese have never been an important commercial meat bird in North America, though they are excellent for smaller families. They also are among the most prolific layers of any geese.

Geese

Size:	Light class (5.5–14 lb. [2.5–6.3 kg]).
Notable Features:	Knob on top of bill; arched and exceedingly slender neck.
Place of Origin:	Unknown.
Conservation Status:	Watch.
Special Qualities:	Talkative and active foragers. Good "weeder" geese (they clean weeds from fields) and also good guard geese.

◊ **Fascinating Fact**

In Dumbarton, Scotland, more than one hundred Chinese geese guarded the famous Ballantine distillery's 25 million gallons of whiskey until the distillery was decommissioned in 2002.

> GANDER

⬦ **Egyptian**

The direct descendants of wild Egyptian geese, domestic Egyptian geese are the smallest geese and also the most colorful. Although fanciers keep Egyptians today, they are still at best semidomesticated birds that should be left to serious fanciers.

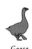

Geese

Size: Light class (5.5–14 lb. [2.5–6.3 kg]).

Notable Features: Reddish purple bill; reddish patches around orange eyes; reddish yellow shanks and feet; iridescent reddish highlights in plumage.

Place of Origin: Egypt.

Conservation Status: Not applicable.

Special Qualities: Among the most aggressive and bad-tempered of all breeds during breeding season. Excellent fliers.

◊ **Fascinating Fact**

The Egyptian's eggs, which are rounder than most bird eggs, held religious significance in Egypt; they were associated with the sun god Ra.

> GANDER

◊ Embden

The tallest geese, Embdens are also heavy and have all-white plumage, making them a popular market fowl for meat production. The Embden is a very old breed of geese. It was first imported to the United States in 1820 from Germany.

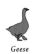

Geese

Size:	Heavy class (22 lb. [10 kg] or more).
Notable Features:	Orange bill, shanks, and feet; blue eyes; white plumage.
Place of Origin:	Germany.
Conservation Status:	Not applicable.
Special Qualities:	Goslings can be sexed up to about three weeks of age. Gentle most of the time; good barnyard bird.

> GANDER

◊ Gray

A traditional barnyard bird, the Gray was the predominant goose throughout the United States and Canada until the 1960s. The Gray has excellent natural reproduction capabilities: a Gray goose can lay 60 or more eggs per year, with high fertility the norm.

Geese

Size: Medium class (14–21 lb. [6.4–9.5 kg]).

Notable Features: Orange bill, shanks, and feet; gray eyes; gray plumage on upper body shading to white on lower body.

Place of Origin: England.

Conservation Status: Study.

Special Qualities: Excellent layer; good, broody mother.

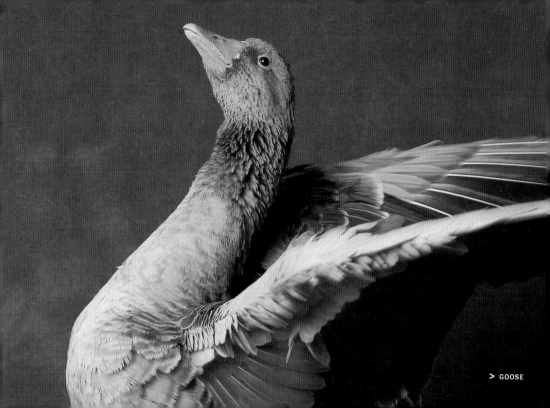

> GOOSE

◊ Pilgrim

Pilgrims are excellent backyard and barnyard birds. While hardy, active foragers, they are among the most easygoing of all goose breeds. They produce a good roasting bird and have been accepted to Slow Food USA's Ark of Taste.

Geese

> GOOSE

Size:	Medium class (14–21 lb [6.4–9.5 kg]).
Notable Features:	Orange bill, shanks, and feet. Bluish gray eyes in gander; hazel brown eyes in goose.
Place of Origin:	United States.
Conservation Status:	Critical.
Special Qualities:	Autosexing color in adult birds is unusual in geese. Excellent parents.

> GANDER

◊ Pomeranian

A practical breed for both meat and egg production, Pomeranians were brought to North America centuries ago with early German settlers. They tend to be boisterous and talkative, so they make good guard animals, but they are not a good choice if neighbors are close by.

Geese

Size: Medium class (14–21 lb. [6.4–9.6 kg]).

Notable Features: Reddish pink to deep tan bill; blue eyes; orangey red shanks and feet. Varieties are Buff Saddleback and Gray Saddleback.

Place of Origin: Germany.

Conservation Status: Critical.

Special Qualities: Unlike most North American domestic geese of European origin, which are descended from the Western Greylag, the Pomeranian is descended from the Eastern Greylag.

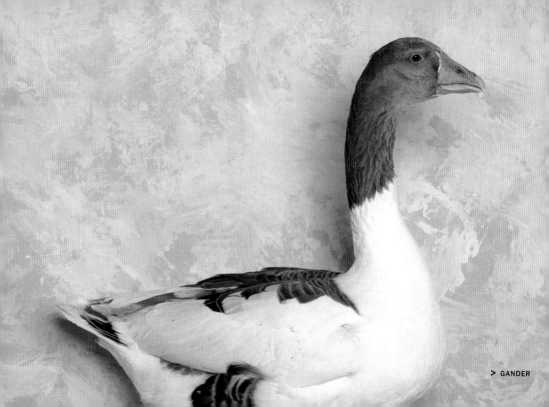

> GANDER

◊ Roman

Developed in Rome over two thousand years ago, the Roman goose comes in two types: tufted and not tufted, though only the tufted type is common in North America. The Roman has a good meat-to-bone ratio and is known for its friendly disposition.

Geese

Size: Light class (5.5–14 lb. [2.5–6.4 kg]).

Notable Features: Pinkish bill; blue eyes; orange to pinkish orange shanks and feet; pure white plumage; tuft of head feathers.

Place of Origin: Italy.

Conservation Status: Critical.

Special Qualities: Good backyard goose. Ideal roaster for family-size meals; females are good layers and mothers.

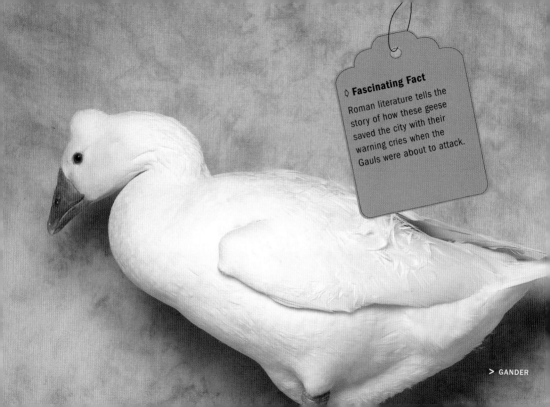

◊ **Fascinating Fact**

Roman literature tells the story of how these geese saved the city with their warning cries when the Gauls were about to attack.

> GANDER

◊ Sebastopol

In North America, Sebastopols are kept primarily as ornamental birds and pets, though they do produce a good carcass and tasty meat. Their striking, long, wavy feathers are up to four times longer than the feathers of other breeds.

Geese

Size:	Medium class (14–21 lb. [6.4–9.6 kg]).
Notable Features:	Orange bill; blue eyes; deep orange shanks and feet; pure white, very long feathers.
Place of Origin:	Southeastern Europe.
Conservation Status:	Threatened.
Special Qualities:	Good personality; hardy.

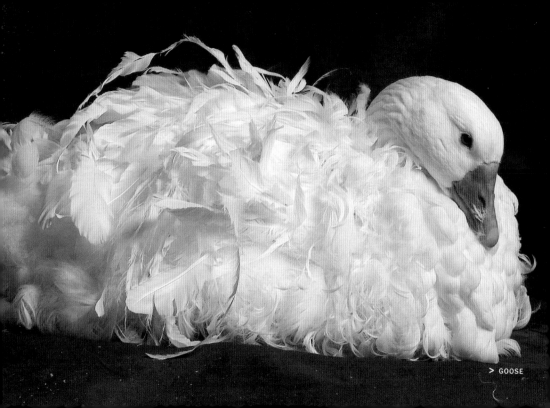

◊ **Toulouse**

An old breed, the Toulouse originated in southern France as a farmyard bird and has been selected for foie gras (liver pâté) production. Today, three types are recognized: Production, Standard Dewlap, and Exhibition.

Size: Heavy class (22 lb. [10 kg] or more).

Description: All three types have loose, fluffy feathers on rump and body. The Exhibition type has extraordinarily large and pendulous dewlaps and large keel.

Place of Origin: France.

Conservation Status: Watch.

Special Qualities: Standard type is more heavily boned and bred to gain weight rapidly for foie gras production.

Geese

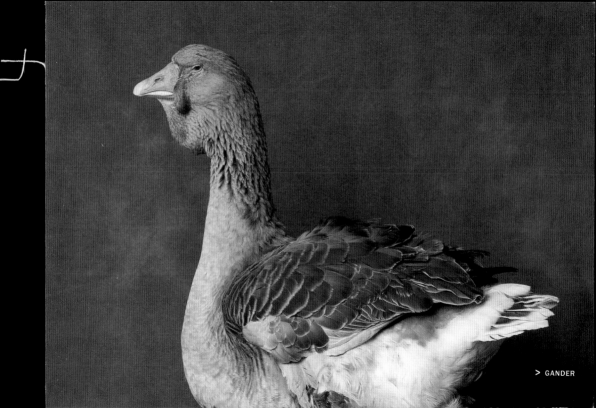

◊ Tufted Buff

A relatively new breed, Tufted Buffs were developed from American Buff ganders and Tufted Roman geese in the early 1990s. They are active birds, but people who keep them report that they are fairly quiet and very friendly.

Geese

Size:	Medium class (14–21 lb. [6.4–9.6 kg]).
Notable Features:	Little bonnet of feathers on top of head. Primarily light yellowish buff plumage (sometimes referred to as apricot-fawn).
Place of Origin:	United States.
Conservation Status:	Not applicable.
Special Qualities:	Prolific layers and eggs tend toward high fertility, but they need very good humidity control when artificially incubated.

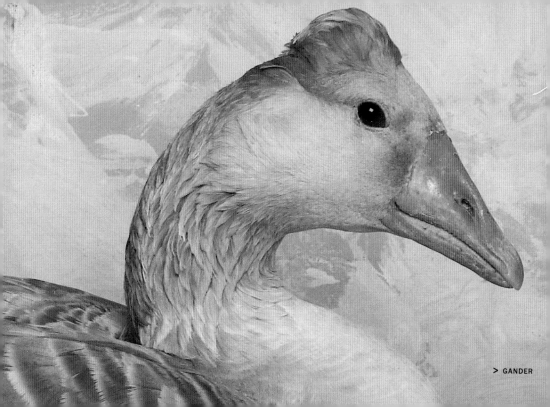

> GANDER

TURKEYS

◊ Black

Originating in North America but developed in Europe, the Black was brought back to North America with early settlers. It was crossbred with wild turkeys to help develop the Bronze, the Narragansett, and the Slate varieties.

Size: **Old Tom.** 33 lb. (14.9 kg) / **Old Hen.** 18 lb. (8.2 kg).

Description: Slaty black beak; dark brown eyes; pink shanks and toes; red head and wattles. Lustrous metallic black plumage.

Place of Origin: United States.

Conservation Status: Critical.

Turkeys

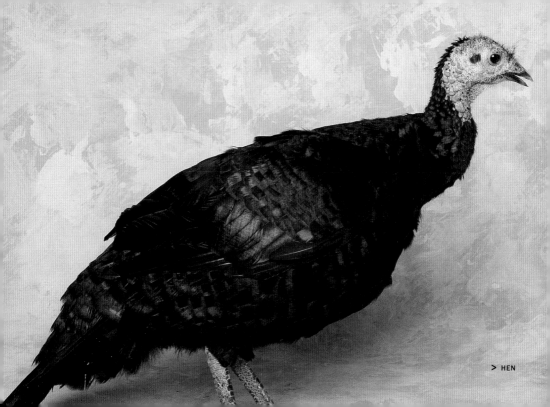

> HEN

◊ Bourbon Red

Developed in the late 1800s, the Bourbon Red has remained popular with small producers thanks to excellent utility traits, such as good foraging capability and richly flavored meat. It has the most breeding birds of any non-industrial heritage breed.

Size: **Old Tom.** 33 lb. (14.9 kg) / **Old Hen.** 18 lb. (8.2 kg).

Notable Features: Deep, brownish red body; pure white tail with soft red bar near end; remainder of plumage dark chestnut mahogany with black edging in males.

Place of Origin: United States.

Conservation Status: Watch.

Turkeys

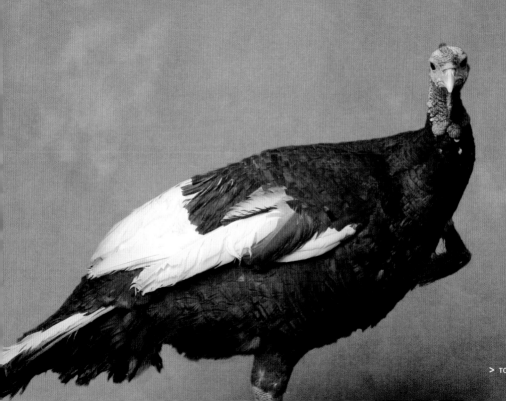

◊ Bronze

The Standard Bronze (shown here) was developed in the United States in the 1700s. In the late eighteenth century, breeders began selecting for a larger breast and legs, ultimately ending up with the Broad-Breasted Bronze. Both types now have very low breeding populations.

Size: **APA* Old Tom.** 36 lb. (16.3 kg) / **Old Hen.** 20 lb. (9.1 kg). **Standard Old Tom.** 34 lb. (15.4 kg) / **Old Hen.** 19 lb. (8.6 kg). **Broad-Breasted Old Tom.** 45 lb. (20.4 kg) / **Old Hen.** 32 lb. (14.5 kg).

Notable Features: Iridescent reddish brown plumage with flecks of green. Broad-Breasted has a large breast and short legs.

Place of Origin: United States.

Conservation Status: **Standard.** Critical. **Broad-Breasted.** Study.

Turkeys

*American Poultry Association

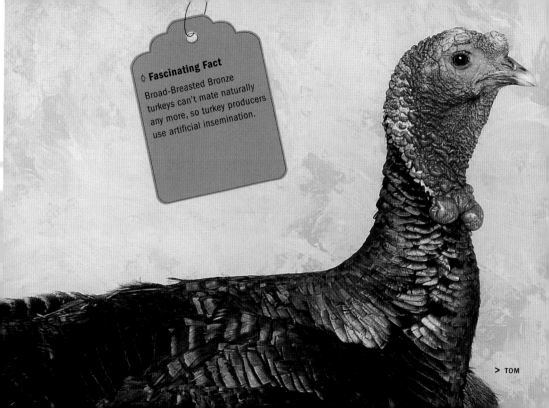

◊ **Fascinating Fact**

Broad-Breasted Bronze turkeys can't mate naturally any more, so turkey producers use artificial insemination.

> TOM

◇ Buff

The Buff was popular in the mid-Atlantic states in the nineteenth century thanks to its light-colored pinfeathers, which made the carcass easy to clean. It was used in developing the Bourbon Red, which quickly ascended in popularity and left the Buff to languish.

Size: **Old Tom.** 25 lb. (11.4 kg) / **Old Hen.** 14 lb. (6.4 kg).

Notable Features: Plumage is evenly buff-colored; light wing and tail feathers.

Place of Origin: United States.

Conservation Status: Critical.

Special Qualities: Breeding for an even buff color is challenging.

Turkeys

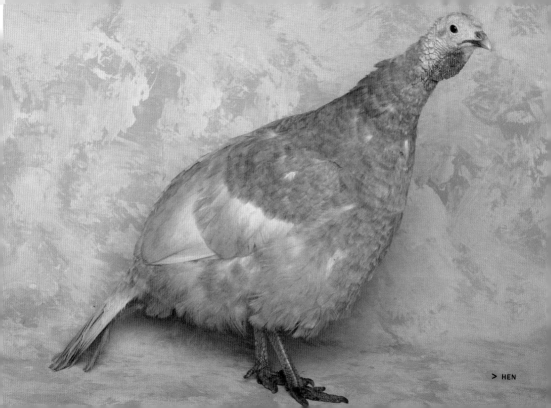

> HEN

◊ Midget White

Similar to the Beltsville Small White (a small, white-feathered turkey), the Midget White is sometimes shown in poultry shows under that classification. It was developed during the late 1950s and early 1960s as a smaller bird for barnyard production.

Size: **Old Tom.** 20 lb. (9.1 kg) / **Old Hen.** 12 lb. (5.5 kg).

Notable Features: Small-sized bird with light-colored pinfeathers.

Place of Origin: United States.

Conservation Status: Critical.

Turkeys

◊ Narragansett

Especially popular in New England during the nineteenth and early twentieth centuries, the Narragansett commanded respect in the mid-Atlantic states and the Midwest. But by the early 1950s its numbers had plummeted.

Size: **Old Tom.** 33 lb. (14.9 kg) / **Old Hen.** 18 lb. (8.2 kg).

Notable Features: Coloring similar to Bronze, but where Bronze has coppery tinge, Narragansett has steely gray color.

Place of Origin: United States.

Conservation Status: Critical.

Special Qualities: Good meat quality; broody; calm.

Turkeys

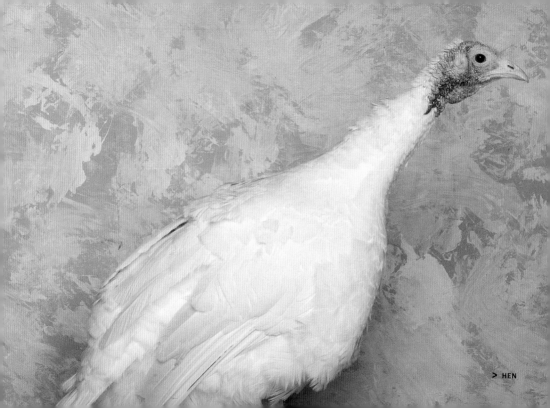

> HEN

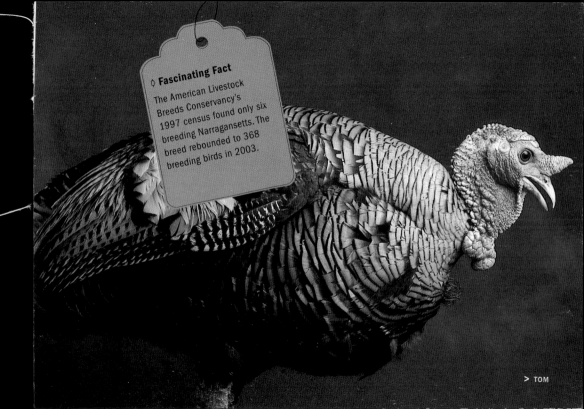

> TOM

◊ Royal Palm

Developed primarily as an ornamental variety for exhibition, the Royal Palm is a lovely bird of medium stature. It is also a great choice for a backyard or a barnyard, producing a nice-sized carcass for a small family meal.

> HEN

Size: **Old Tom.** 22 lb. (10 kg) / **Old Hen.** 12 lb. (5.5 kg).

Notable Features: Royal Palm (at right) has white wings, breast and body with black across each feather. Blue Palm subvariety (at left) has bluish brown highlights; Golden Palm subvariety has creamy golden tint.

Place of Origin: United States.

Conservation Status: Watch.

Turkeys

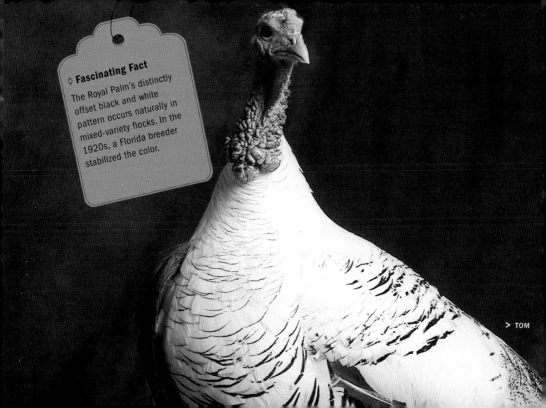

> TOM

◊ Slate

The Slate has a bluish gray base color splattered with bluish black spots. Breeding for the show-quality slate color is a challenge.

Size:	**Old Tom.** 33 lb. (14.9 kg) / **Old Hen.** 18 lb. (8.2 kg).
Notable Features:	Horn beak; dark brown eyes; pink shanks and toes; red head and wattles. Slaty blue plumage.
Place of Origin:	United States.
Conservation Status:	Critical.
Special Qualities:	Old birds bred from an early Pennsylvania State University strain may develop an unusual form of cataracts that can lead to blindness.

Turkeys

> TOM

◊ White Holland

Imported to the United States in 1874, the White Holland quickly became popular for commercial production thanks to its white pinfeathers, but it dwindled quickly after the 1950s, when it was replaced by the Broad-Breasted White (the most commonly raised commercial turkey).

Size:	**Old Tom.** 36 lb. (16.3 kg) / **Old Hen.** 20 lb. (9.1 kg).
Notable Features:	Light pinkish horn beak; dark brown eyes; pinkish white shanks and toes; red head and wattles. Pure white plumage.
Place of Origin:	Holland or Austria.
Conservation Status:	Critical.
Special Qualities:	Excellent for small-scale turkey production.

Turkeys

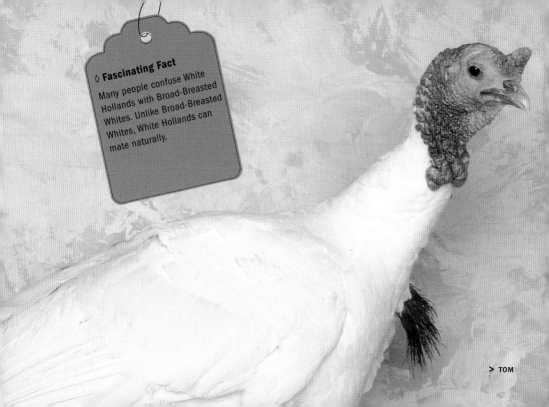

◊ **Fascinating Fact**

Many people confuse White Hollands with Broad-Breasted Whites. Unlike Broad-Breasted Whites, White Hollands can mate naturally.

> TOM

◊ Conservation Status Terms

Under the category CONSERVATION STATUS, we have used designations established by the American Livestock Breeds Conservancy (ALBC) for its Conservation Priority List. These designations are based on the estimated number of breeding birds and breeding flocks.

Critical. Fewer than 500 breeding birds in the United States, with five or fewer primary breeding flocks (50 birds or more), and globally endangered.

Threatened. Fewer than 1,000 breeding birds in the United States, with seven or fewer primary breeding flocks, and globally endangered.

Watch. Fewer than 5,000 breeding birds in the United States, with ten or fewer primary breeding flocks, and globally endangered. Also included are breeds with genetic or numerical concerns or limited geographic distribution.

Recovering. Breeds that were once more threatened but still need monitoring.

Study. Breeds that are of interest but lack genetic or historical documentation.

Not Applicable. The ALBC has not listed this breed, due to a number of reasons: the breed has sufficient breeding birds; continuous breeding populations were never established in North America; the foundation stock is no longer available; or the global population is sufficient to protect a breed that isn't traditionally important in North America.

⇨ Common Chicken Colors

Below are descriptions for the most common chicken plumage colors and patterns. These are only generalized descriptions, and these colors can manifest differently from breed to breed.

Barred
Feathers are crossed with sharply defined bars of one color (usually black or slate) against another (usually white or cream).

Birchen
White to silvery white head; white neck and upper breast with black stripe down middle of each feather, transitioning to black feathers with white lacing; black lower breast, body, legs, wings, and tail. **Rooster:** Back and saddle are similar to neck. **Hen:** Black to brownish black back.

Black
Uniformly black plumage, from shiny greenish black to duller black, over entire body in both sexes.

Black-Breasted Red
Rooster: Predominantly black plumage; creamy white head and hackle; golden back; black wings with red and green highlights. **Hen:** Reddish brown plumage with black highlights in tail and wings.

Black-Tailed Red
Primarily rich, lustrous dark red plumage; mainly black tail; red wings with some black highlights; deep red undercolor.

Blue

Lustrous bluish black to slaty blue head; uniform slaty blue plumage, laced with bluish black, over rest of body.

Blue Red

Rooster: Light orange head; golden red hackle and saddle; rich red back; blue front of neck, breast, body, legs, and tail; blue wings with red and bay highlights. **Hen:** Orangey red head; light orange hackle with a blue stripe in middle of each feather; light salmon to ashy gray front of neck and breast; bluish gray body, wings, legs, and tail, stippled with brown.

Brown Red

Bright orange head. **Rooster:** Predominantly black plumage with red back and saddle. **Hen:** Primarily brownish black plumage with reddish brown back and top of head.

Buff

Golden buff plumage throughout.

Buff Columbian

Primarily buff body, breast, and legs; black hackle (and cape and saddle on roosters) with buff lacing; primarily black tail with buff highlighting; primarily buff wings with black highlighting.

Columbian

Primarily white body, breast, and legs; black hackle (and cape and saddle of roosters) with white lacing; primarily black tail with white highlighting; primarily white wings with black highlighting.

Crele

Rooster: Barred orange-red against pale straw head, hackle, back, and saddle; barred gray and white plumage over rest of body.

Hen: Pale gold head and hackle barred with grayish brown; salmon to ashy gray front of neck and breast; dark gray to ashy gray plumage with some barring over rest of body.

Cuckoo

Bluish white plumage barred with irregular light and dark bars. Hen is slightly darker than rooster.

Dark

Rooster: Lustrous greenish black plumage; dark red shafts and centers of hackle and back feathers; black barring and bay on wings. **Hen:** Greenish black head; greenish black hackle with bay shafts; reddish mahogany neck, breast, and body with black lacing; black tail and legs, with some bay penciling; mahogany fronts, bows, and coverts of wings, laced with black; black primaries and secondaries of wings, with bay penciling.

Dark Brown

Red head; dull slatelike black undercolor.
Rooster: Red hackle, back, and saddle, with a greenish black stripe on each feather; lustrous greenish black front of neck; black breast, body, legs, and tail; primarily red to reddish brown wings with black highlights.
Hen: Red hackle with a greenish black stripe on each feather; black front of neck, back, breast, legs, tail, and wings, with stippling of reddish brown.

Ginger Red

Rooster: Lustrous red head and back; lustrous yellowy orange hackle and saddle; ginger-red front of neck and breast; dusky red body and legs; black wings and tail, highlighted in red and ginger. **Hen:** Ginger-yellow head, breast, and front of neck; golden yellow hackle striped with black; ginger-yellow back

stippled with black; dull ginger body and legs; black tail stippled with ginger; ginger wings highlighted with black.

Golden
Rooster: Creamy white head and hackle; gold back; black front of neck, breast, body; golden wings with black and white highlights. **Hen:** Primarily light to dark gray, with salmon-colored front of neck and breast; black tail with gray highlighting; gray wings with brownish black highlights.

Golden Duckwing
Rooster: Mainly black; cream-colored head and hackle; gold-colored back; golden highlights on wings and tail. **Hen:** Primarily shades of gray; salmon-colored front of neck and breast; black highlights in tail; dark brown highlights in wings.

Golden Penciled
Rooster: Predominantly solid golden red; bright greenish black tail with distinct golden red border; some black bars on wings. **Hen:** Golden red head and hackle; black and gold barred feathers over rest of body, wings, and tail.

Golden Spangled
Rooster: Solid golden red head; golden red hackle and saddle with a greenish black stripe on each feather. Spangled black front of neck, breast, back, body, wings, and legs; solid, lustrous greenish black tail. **Hen:** Golden red with large black spangles over most of body; primarily greenish black tail.

Gray
White to silvery white head. **Rooster:** Silvery white hackle with a black stripe on each feather; black breast and front of

neck with silvery white lacing; white back with silver luster; black body and tail; black wings highlighted with silvery white. **Hen:** Black neck and breast with white lacing; black plumage over rest of body.

Lemon Blue

Lustrous lemon yellow head; lemon hackle with a slate blue stripe on each feather; slate blue upper breast with a narrow lacing of lemon; slate blue (darker in rooster) lower breast and body, tail, legs, shank, and outer toe. **Rooster:** Lemon cape; lemon saddle with slate blue stripe; slate wings with lemon highlights. **Hen:** Slate blue back and wings.

Light Brown

Rooster: Orange hackle at head, golden yellow at shoulder; black front of neck highlighted by salmon; orangey red back and saddle; black breast, body, legs, and tail; orangey red wings highlighted with black. **Hen:** Light orange hackle with a black stripe on each feather; rich salmon front of neck and breast; dark brown body, back, coverts, and wings stippled with a lighter shade of brown; primarily black tail with some brown stippling.

Mille Fleur

Primarily orange plumage with white and greenish black accents. **Rooster:** Orangey red head feathers tipped with white and black; rich orangey red hackle feathers; golden front of neck, breast, and body; deep reddish gold back and wings (wings have black and white stippling); primarily black tail highlighted with white. **Hen:** Similar to the rooster, but back, saddle, and wings are the same shade of gold as neck and breast.

Mottled

Black plumage with white V-shaped markings on some tips. In roosters, the black is highly lustrous; in hens, it is a little duller.

Partridge

Red to reddish bay head. **Rooster:** Lustrous greenish black hackle, back, and saddle, laced with red; black front of neck, breast, and body; black stern tinged with red; lustrous black tail; black and red wings. **Hen:** Penciled reddish bay and black plumage.

Porcelain

Primarily beige to lustrous straw plumage; slaty highlights on wings; slaty blue tail with beige and white highlights.

Red

Brilliant plumage; may be slightly less glossy in hen.

Red Pyle

Rooster: Bright orange head; lighter orange hackle and saddle; white front of neck, possibly tinged with bright yellow; red back; white breast, body, legs, and tail; white wings highlighted with black and red; light slate undercolor. **Hen:** Gold head; white hackle edged with gold; white front of neck tinged with salmon; salmon breast; white plumage over rest of body.

Self Blue

Even shade of slaty blue plumage over entire body.

Silver

Rooster: Shiny greenish black body; silvery white head, back of neck, back, and saddle. **Hen:** Solid silver head; dull black tail; grayish to reddish brown plumage over rest of body

with thin stripes of silver down the middle of most feathers.

Silver Duckwing

Rooster: White head; silvery white hackles; silvery white back; black front of neck, breast, and body; silvery white tail and wings. **Hen:** Primarily shades of silver to light gray; pale salmon front of neck and breast; black tail with gray highlights; black and gray wings.

Silver Laced

Plumage is composed primarily of laced feathers. Black upper body laced with silvery white to silvery gray; silver lower body laced with black; black tail.

Silver Penciled

Rooster: Silvery white head, neck, breast, back, and legs; solid black tail; black tail sickles and coverts with white edging.

Hen: Solid white head; penciled black and silvery white plumage on rest of body; slate undercolor.

Silver Spangled

Slate undercolor in both sexes. **Rooster:** Pure white head; black spangles on rest of body, beginning at neck. **Hen:** Fully spangled (black against silvery white) body; tail has more white exposed.

Spangled

Rooster: Rich red head, hackle, back, and saddle, with white spangles; black breast, body, tail, wings, and legs, with white spangles. **Hen:** Golden red to salmon head and hackle, striped with black; black back, tail, and wings, stippled with brown, with some white spangling; salmon breast, body, and legs, stippled with brown and spangled with white, offset by black bars.

Splash
Plumage has irregularly shaped, slaty blue blobs against a white background tinged with bluish gray.

Wheaten
Rooster: Shiny greenish black breast, body, and tail; bright golden red head, neck, back, and over saddle; black beard and muffs; wings have a reddish brown stripe on shoulder and bow. **Hen:** Tan to golden yellow plumage over most of body, with some black in tail.

White
White plumage throughout, varying from lustrous to dull.

White-Laced Red
Rich red plumage with white lacing throughout.

◊ Chicken Colors, Breed by Breed

Of the four species in this book — chickens, ducks, geese, and turkeys — chickens, by far, come in the widest variety of colors. For those chicken breeds accepted by the American Poultry Association, only the colors accepted by the association have been listed.

Ameraucana
Black; Blue; Blue Wheaten; Brown Red; Buff; Silver; Wheaten; White.

American Game Bantam
Birchen; Black; Black-Breasted Red; Blue; Blue Red; Brassy Back; Brown Red; Golden Duckwing; Red Pyle; Silver Duckwing; Wheaten; White.

Ancona
Shiny greenish black with white mottling.

Andalusian
Blue.

Appenzeller
Black; Golden Spangled; Silver Spangled.

Araucana
Black; Black-Breasted Red; Blue; Buff; Golden Duckwing; Silver; Silver Duckwing; White.

Aseel
Black-Breasted Red; Dark; Spangled; Wheaten; White.

Australorp
Black.

Bearded d'Anvers Bantams
Black; Black-Breasted Red; Blue; Blue Quail; Buff; Buff Columbian; Columbian; Cuckoo; Mille Fleur; Mottled; Porcelain; Quail; Self Blue; White.

Blue Hen of Delaware
Steely blue with some yellow and orange.

Booted Bantam & Bearded d'Uccle
Black; Blue; Buff; Golden Neck; Gray; Mille Fleur; Mottled; Porcelain; Self Blue; White.

Brahma
Black; Buff; Dark; Light; White.

Buckeye
Rich reddish brown with some black in tail.

Campine
Golden; Silver.

Catalana
Buff with greenish black tail.

Chantecler
Partridge; White.

Cochin
Barred; Birchen; Black; Black-Tailed Red; Blue; Brown; Brown Red; Buff; Buff Columbian; Columbian; Golden Laced; Lemon Blue; Mottled; Partridge; Red; Silver Laced; Silver Penciled; White.

Cornish
Black; Blue; Blue-Laced Red; Buff; Columbian; Dark; Jubilee; Mottled; Silver Laced; Spangled; White; White-Laced Red.

Crevecoeur
Black.

Cubalaya
Black; Black-Breasted Red; Red Pyle; White.

Delaware
White to silvery white with some black barring.

Dominique
Barred.

Dorking
Colored; Cuckoo; Red; Silver Gray; White.

Dutch Bantam
Black; Blue; Blue Light Brown; Cuckoo; Golden; Light Brown; Self Blue; Silver; Wheaten; White.

Faverolle
Black; Blue; Buff; Salmon; White.

Fayoumi
Silvery white with black barring.

Hamburg
Black; Golden Penciled; Golden Spangled; Silver Penciled; Silver Spangled; White.

Holland
Barred; White.

Houdan
Mottled; White.

Iowa Blue
Bluish black to gray with some silvery white plumage.

Japanese Bantam
Barred; Black; Black-Breasted Red; Black-Tailed Buff; Black-Tailed Red; Black-Tailed White; Blue; Brown Red; Buff; Gray; Mottled; Self Blue; Silver Duckwing; Silver Laced; Wheaten; White; White Bearded.

Java
Black; Mottled; White.

Jersey Giant
Black; White.

Kraienkoppe
Black-Breasted Red; Silver.

La Fleche
Black.

Lakenvelder
Black and white.

Langshan
Black; Blue; White.

Leghorn
Barred; Black; Black-Tailed Red; Blue; Buff; Buff Columbian; Columbian; Dark Brown; Dominique; Exchequer; Golden; Light Brown; Mille Fleur; Red; Silver; White.

Malay
Black; Black-Breasted Red; Red Pyle; Mottled; Spangled; Wheaten; White.

Maran
Birchen; Black; Black-Tailed Buff; Brown Red; Columbian; Golden Cuckoo; Silver Cuckoo; Wheaten; White.

Minorca
Black; Buff; Self Blue; White.

Modern Game
Barred; Birchen; Black; Black-Breasted Red; Blue; Blue-Breasted Red; Brown Red; Crele; Cuckoo; Ginger Red; Golden Duckwing; Lemon Blue; Red Pyle; Self Blue; Silver Blue; Silver Duckwing; Wheaten; White.

Naked Neck
Black; Blue; Buff; Cuckoo; Red; White.

Nankin
Orangey red to chestnut to golden buff with black tail.

New Hampshire
Golden bay to chestnut red with some black in tail.

Old English Game
Barred; Birchen; Black; Black-Breasted Red; Black-Tailed Buff; Black-Tailed Red; Black-Tailed White; Blue; Blue Brassy Back; Blue-Breasted Red; Blue Golden Duckwing; Blue Silver Duckwing; Blue Wheaten; Brassy Back; Brown Red; Buff; Columbian; Crele; Cuckoo; Fawn Silver Duckwing; Ginger Red; Golden Duckwing; Lemon Blue; Mille Fleur; Mottled; Quail; Red Pyle; Self Blue; Silver Blue; Silver Duckwing; Spangled; Splash; Wheaten; White.

Orloff
Black-Tailed Red; Spangled; White.

Orpington
Black; Blue; Buff; White.

Penedesenca
Black; Crele; Partridge; Wheaten.

Phoenix
Black; Golden; Golden Duckwing; Light Brown; Silver; Silver Duckwing; White.

Plymouth Rock
Barred; Black; Blue; Buff; Columbian; Partridge; Silver Penciled; White.

Polish
Black-Crested White; Blue; Buff Laced; Golden; Silver Laced; White; White-Crested Black; White-Crested Blue; White-Crested Chocolate; White-Crested Cuckoo.

Redcap
Red, black, and brown, with some golden bay in hen.

Rhode Island Red
Red with black tail.

Rhode Island White
White.

Rosecomb
Barred; Birchen; Black; Black-Breasted Red; Black-Tailed Red; Blue; Brown Red; Buff; Buff Columbian; Columbian; Crele; Exchequer; Ginger Red; Golden Duckwing; Lemon Blue; Mille Fleur; Mottled; Porcelain; Quail; Red; Red Pyle; Silver Duckwing; Splash; Wheaten; White.

Sebright
Golden; Silver.

Serama
Seramas can appear in almost any color. There are no standards for color.

Shamo
Black; Black-Breasted Red; Brown Red; Buff Columbian; Dark; Spangled; Wheaten; White.

Sicilian Buttercup
Rooster is lustrous reddish orange to reddish bay with black tail and wings; hen is golden buff with black spangles.

Silkie
Black; Blue; Buff; Gray; Partridge; Splash; White.

Sultan
Black; Blue; White.

Sumatra
Black; Blue; White.

Sussex
Birchen; Buff; Dark Brown; Light; Red; Speckled; White.

Vorwerk Bantam
Buff and black.

Welsummer
Golden brown to reddish brown and black.

White Faced Spanish
Black.

Wyandotte
Barred; Birchen; Black; Black-Breasted Red; Blue; Blue Red; Brown Red; Buff; Buff Columbian; Columbian; Golden Laced; Lemon Blue; Partridge; Silver Laced; Silver Penciled; Splash; White; White-Laced Red.

⇗ Useful Web Sites

Breed Clubs

Ameraucana
www.ameraucana.org

American Game Bantam Breeders Association
http://rosenagb.webs.com

Araucana
www.araucana.net

Australorp
www.australorps.com

Bearded d'Anver
http://danverclub.webs.com

Booted Bantam and Bearded d'Uccle
www.belgianduccle.org

Brahma
www.theamericanbrahmaclub.org

Cochin
http://cochinsinternational.cochinsrule.com

Cubalaya
http://groups.yahoo.com/group/cubalaya breedersclub

Dominique
www.dominiqueclub.org

Dutch Bantam
www.dutchbantamsociety.com

Faverolle
www.faverollesfanciers.org

Hamburg
www.northamericanhamburgs.com

Japanese Bantam
http://home.roadrunner.com/~jbba/JBBA.html

Langshan
http://tech.groups.yahoo.com/group/Langshans

Leghorn
www.crohio.com/ablc

Maran
http://maransofamericaclub.com

Old English Game
www.bantychicken.com/OEGBCA

Orpington
www.unitedorpingtonclub.com

Plymouth Rock
www.showbirdbid.com/joomla/rockclub

Polish
www.polishbreedersclub.com

Rhode Island Red
www.crohio.com/reds

Rosecomb
www.rosecomb.com/federation

Serama
www.seramacouncilofnorthamerica.com

Sicilian Buttercup
www.americanbuttercupclub.com

Silkie
www.americansilkiebantamclub.org

Wyandotte
http://wyandottebreedersofamerica.com

Other Organizations

American Bantam Association
www.bantamclub.com

American Livestock Breeds Conservancy
www.albc-usa.org

American Pastured Poultry Producers' Association
www.apppa.org

American Pheasant and Waterfowl Society
www.apwsbirds.com

American Poultry Association
www.amerpoultryassn.com

Heritage Turkey Foundation
www.heritageturkeyfoundation.org

National Wild Turkey Federation
www.nwtf.org

North American Gamebird Association
www.mynaga.org

Pet Duck Association
http://pets.dir.groups.yahoo.com/group/ petduckassociation

Slow Food USA
www.slowfoodusa.org